HELL

Published by Oyster Point Press, Charleston, SC

www.oysterpointpress.com

Paperback ISBN-13: 9780991042593
eBook ISBN-13: 9780991516001

HELL

MY LIFE IN THE SQUIRREL NUT ZIPPERS

A MEMOIR

TOM MAXWELL

OYSTER POINT PRESS

CONTENTS

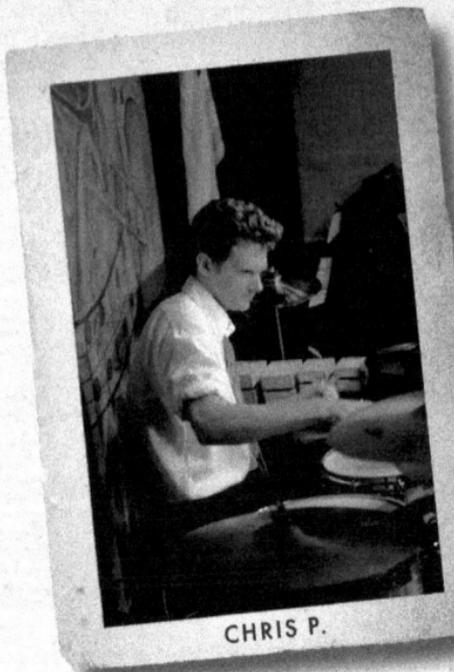
CHRIS P.

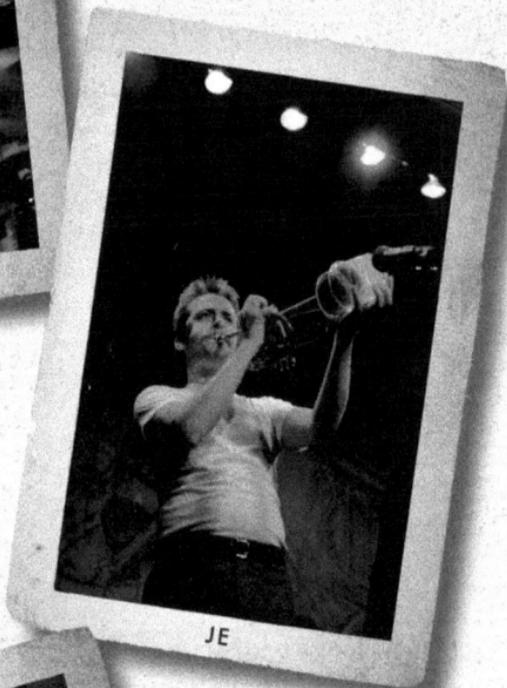
JE

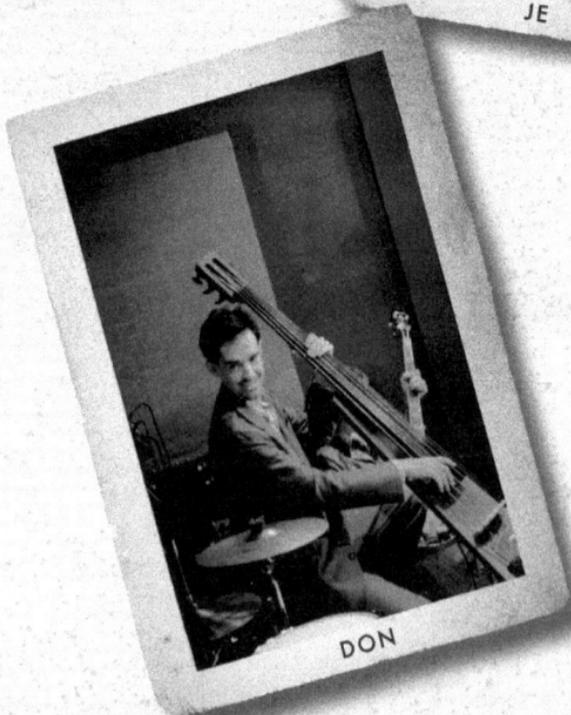
DON

JIMBO

KEN

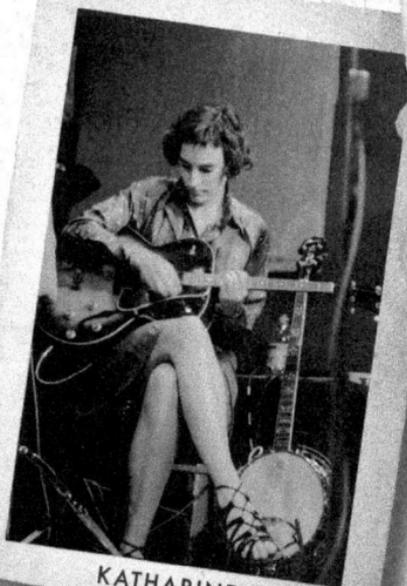

KATHARINE

TOM

CHAPTER ONE

I'VE FOUND A NEW BABY

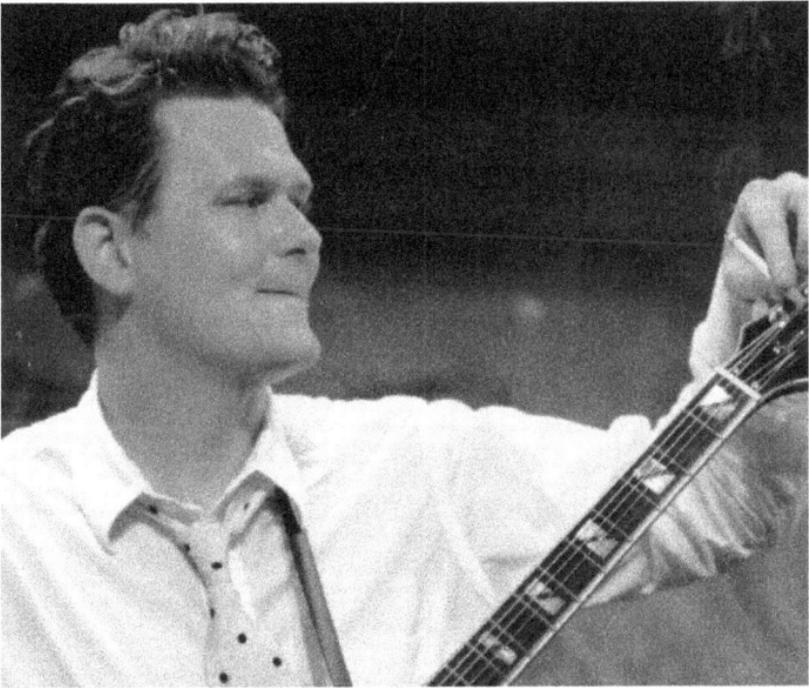

IT WAS JANUARY 1994, AND JIMBO HAD ASKED ME to drop by a Squirrel Nut Zippers rehearsal. I had done it before; these guys were friends of mine. Jimbo Mathus was from Clarksdale, Mississippi. He talked like it, sang like it. He once worked on a barge, and later wrote a song called "Slophouse" about being a dishwasher.

I'd worked in the slophouse too. Most of us still did. If you're in a band, you need a crappy job just to keep body and soul together. You need a schedule that's flexible enough to allow you to practice two nights a week. One summer in college I was a dishwasher at a cafeteria that used bleach to mop the floors every night. After some shifts I'd run my black-caked high tops through the industrial dish machine just to start from scratch. They came out hot and wet and clean.

Jimbo had a small frame and a lot of energy. In the coming months, we would occasionally walk through the woods near his house with his dog, Shorty Brown, and Jimbo would point out things like The Buzzard House, a fallen-down shack with a turkey buzzard living in the attic. He took inspiration from everything and wrote songs that sounded like Tom Waits scoring a William Faulkner script. He had a gold tooth that would shine, and although he started out as a good guitar player, he got great. And the better he got, the brighter that tooth would shine.

My girlfriend, Mel, and I used to double date with Jimbo and his girlfriend, Katharine. We'd dance to Fats Waller records in my little Carrboro house. They were an odd couple: Jim was wiry, with a quick laugh, and a feral look. Katharine was more robust and resembled Frida Kahlo. She made paintings and collages and experimented

with stop-motion animation. People said her voice sounded like a combination of Billie Holliday and Betty Boop. She was a fine banjo player, especially considering she had just learned the instrument the previous year; however, she was always the reluctant musician. To maintain balance in the coming years, she continued painting and insisted we only tour two weeks out of the month.

The band formed around Jim and Katharine's budding romance. Jimbo made marionettes and Katharine clothed them. They were married and, at least for the time, a singular entity. They were very much in love, as I was with Mel, a slender tomboy from Charlotte.

Mel and I had attended a practice at Jim and Katharine's decrepit farmhouse the year before. The band did as normal: fry chicken, drink bourbon, and make music. Mel and I sat on the porch swing and listened, at least until the chains pulled out of the rotted ceiling and we crashed to the floor. We laughed and refreshed our drinks. Later I sat in on drums for a song or two.

On this day I had been asked to come to a rehearsal over at Don Raleigh's house. Don was the Zippers' bass player. He was small, dark, and monosyllabic. I don't suppose Don was any weirder than the rest of us, but he was older, and therefore subject to more abuse. Because of his indeterminate age and darkened house, we called him The

Bat. Don had his own genius, though. He turned us on to Harry Partch and convinced everybody during the fierce Scrabble tournaments in the van that "yi" was a word.

"That's not a word," we said.

"Of course it is. It's an exclamation: 'Yi, Don's winning at Scrabble again!'"

We let him play it and later found out that *of course it's not a word*. That is, until we started using it all the time. "Yi, I just met Dick Clark!"

I had shown up at the rehearsal without drumsticks. It was suggested that Don could provide a couple spoons— something for me to hit the snare drum with. But Don only had one of everything—one spoon, one bowl, one glass—which I figured pegged him as a committed bachelor. The exception was toothbrushes, of which he had two. I played with those. We ran through many of the band's songs, most of which I already knew.

Ken Mosher gave up his drum seat for me. To call Ken colorful is to do him a disservice. Around the time the band formed, and for reasons known only to him, he painted his lawn blue. Soon after I joined the band, he pierced his nose with a carrot and a nail and created a shockingly accurate and illegal facsimile of a state auto inspection sticker with crayons. His wardrobe was limited to cut-off overalls, sweater vests, and a pith helmet, and

his auburn hair was a kind of slow motion explosion.

Ken was the band's clutch player. He could play a little drums and a lot of guitar. He had a global perspective on a song, beyond his individual part. Ken was not an encyclopedia of pre-war jazz, but that didn't matter. His description of the Squirrel Nut Zippers was definitive: "We're just a pop band that plays weird instruments." Ken *got* whatever he heard, and he listened to everything. During the sessions for our first record he remembered he played saxophone in middle school, like me. Unlike me, he got his hands on one and used it on the record. I started playing sax again too, because of Ken. I did a lot of idiotic things because of Ken.

Chris Phillips stayed on the contraption kit, a strange assemblage of bass drum, woodblocks, cowbell, and choke cymbal. Tall, skinny, and redheaded, Chris P was a big part of the band's sound. I was happy playing rhythm guitar like Al Casey or Django Reinhardt, but Chris brought the most telling DIY aesthetic. As a teenager, he drummed for the punk band Subculture. Although capable of subtlety— even musicality—his playing was often propulsive and loud as bombs. Chris's sense of humor was highly developed and often cutting. His abrasiveness, I figured, hid vulnerability. Sometimes he was just a grouch. That night, he didn't seem to be too excited to see me.

So I played a snare drum with Don's toothbrushes,

wondering what the hell I had gotten into.

When they formed, the Zippers seemed so self-contained I didn't think there was a place for me. By the time we played together at Don's house, they already had a cult following in Chapel Hill. My own band, What Peggy Wants, didn't disintegrate until late 1993, around the time the first Zippers' EP was released. I began forming The Minor Drag, playing a few old school jazz songs I wrote. I developed a lot of my compositional technique because of a gift from my childhood from a guy named Rice Fitzpatrick.

Rice lived on the mountain where I grew up. He was lanky and white-haired. A clarinet and a banjo hung from the walls of his cabin, and my parents told me he had been in a jazz band in the 20s. I wish now that I had shown more interest. When Rice heard I was learning alto saxophone, he gave me his Fake Book.

A Fake Book is a handy thing for a jazz musician. Filled with the popular songs of the day, it gives a bare-bones outline of each tune: chord changes, melody, and lyrics. Possessing one, and a decent technique, means that you can sit in with pretty much anybody and have a clue what's being performed. There are no songs in Rice Fitzpatrick's Fake Book written after 1949. My parents fussed over the gift. "This is important," they said. "Keep it in a safe place." I did just that, placing the book on a shelf and forgetting about it.

My folks bought me a drum kit during high school. It came in pieces over Christmases and birthdays: a floor-tom here, a snare drum there. Before then, I would listen to records with headphones, playing air drums and using pencils for sticks. I listened to rock and roll: the Beatles, Stones, and Led Zeppelin records my older brother Dan brought home, as well as the Yardbirds, Velvet Underground, and Small Faces. I was in a band before I graduated from college. Chapel Hill is that kind of place, and by the late 80s, it was starting to give Athens, Georgia competition as the happening indie scene. I began my career of only being in bands with three-word names. The first was called Teasing the Korean, named after a song on a James Bond soundtrack. This band morphed into What Peggy Wants. John Ensslin was lead singer for both bands.

John was one of the first people I met at college. At the time, he was chubby and wore horn-rimmed glasses and bleached blond hair. Although John had different tastes than me, we bonded over music and he turned me on to The Cure and The Fall, and stranger bands like The Virgin Prunes. Most of all, he showed me how to write lyrics and front a band. His lyrics were marvelous; he wrote the words for my first Zippers offerings, "Plenty More" and "Club Limbo." He has a knack for double meanings and evocative imagery. On stage, John is quite a force. His body

language is angular and obscure. Stylistically, we're very different writers and performers, but John taught me the fundamentals of going with your gut, working on a lyric, and not being self-conscious on stage.

One night, after returning home from a gig, I saw a clip of Cab Calloway on TV. He was singing "Minnie the Moocher" in the early 1930s, decked out in white tails. Cutout lightning bolts hung over the bandstand. I was transfixed. Cab was so creepy and elegant. He didn't have to beat your brains out with volume to rock. I started buying his CDs. From Cab, it's a short hop for the interested listener to finding Fats Waller, Duke Ellington, and Django Reinhardt. Rice Fitzpatrick's Fake Book was soon retrieved and soon became my master class in composition.

The boys in What Peggy Wants indulged my growing interest in old school jazz. They listened enthusiastically and played some of the new songs I was writing. Tim Roven, the guitarist, grew up studying violin and had a decent swing technique. Jeff Taylor bought an acoustic bass like the one the guy had in the Violent Femmes. We'd do acoustic sets of this material and some old jazz covers, then return to the loud stuff. It made for some schizophrenic sets. In 1991, we got signed to a local label with the unfortunate name of Moist/Baited Breath, along with a few other local acts. One of them was called Metal Flake Mother.

I had known most of the guys in Metal Flake Mother from other bands. Ben, the short, twitchy songwriter, singer, and guitarist, had been in the Chapel Hill music scene since he was a teenager. I went to college with Quince Marcum, the loveable bass player. Randy Ward, the cool cat lead guitarist, was also an established player. The band's drummer, though, was a recent transplant from Clarksdale, Mississippi. He had crooked teeth and wore a battered top hat. People called him Jimbo. Together, they sounded like the Pixies covering Dick Dale in the woods at night.

In 1991, Metal Flake Mother released a phenomenal album, *Beyond the Java Sea*. It made a deep impression on the Chapel Hill scene. Ben and Jimbo wrote most of the songs. Ben sang his with a kind of desperate shriek; Jimbo's vocals were more laconic. His images were dreamlike and rural. He was such a natural singer and drummer that he reminded me of Levon Helm from The Band, which is about the most anybody could wish for.

Jimbo was animated and friendly. We struck up a friendship. He would come into the restaurant where I tended bar and hang out. I played him the hot jazz that had so captivated me; he introduced me to Robert Crumb's Cheap Suit Serenaders, a wonderfully uncool, early 70s Squirrel Nut Zippers prototype. We watched old Max Fleischer cartoons together, especially the strange Betty Boop episodes

that featured artists like Cab and Louis Armstrong. When Randy left Metal Flake Mother, Jimbo switched to rhythm guitar, and I was asked to sit in on drums. It didn't last. Metal Flake Mother spun apart in the first few months of 1993. Given their eccentricities, it made sense that the members would go their separate ways. But I believe their demise was hastened by Chapel Hill's recent media attention as The New Seattle.

The Grunge scene had solidified across the country. I understand now that it was a total construct—about the only thing Mudhoney and Pearl Jam had in common was their hometown and some bar tabs. For an industry that was becoming ever more centralized, Grunge was a godsend. It helped with playlists for radio stations increasingly owned by Clear Channel, and gave an excuse for music writers to write less about music. There was a scene now, and an agreed-to sound to go with it, and a way of dressing. In the early 90s it was decided that Chapel Hill—possibly the most diverse musical town in the country—was the heir of the movement. A few groups like Superchunk, Archers of Loaf, and Polvo sort of had the sound, but many other great bands were ignored and broke up. Metal Flake Mother could have survived, but their record didn't fit the mold. The writing was also on the wall for What Peggy Wants. We played better and

better shows for fewer and fewer people.

As we drove around Carrboro one spring day in 1993, Jimbo turned to me. "I'm forming a jazz band," he said intently. I knew exactly what he meant. The jazz we listened to was almost all pre-war. I didn't think for a second that any group Jimbo would form would sound like Miles Davis or Ornette Coleman. It would be acoustic and Southern and strange. Jimbo had already written a couple Metal Flake Mother songs that signaled the direction: "Ghosts in the Friendly Barber Shop," which sounded like a Fleischer cartoon, and "Stoughton, Mass," a sweet ballad with jazzy, descending chords.

"That's great!" I told him through my teeth. I wanted to be in that outfit. Jimbo wrote fantastic songs and had a gifted musical instinct. I loved the guys in What Peggy Wants and wasn't going to bail on them. Still, I longed to make the kind of music Jimbo and I had been listening to.

By this time, Mel and I were hanging out with Jimbo and Katharine. I had seen Katharine around town before. She had a masculine, standoffish look, but when I got to know her I found out she was quiet and sweet. We watched Nirvana play *Saturday Night Live* together. "That's the end of Grunge," I told Jimbo. I couldn't see how alternative music could go mainstream, because then it would be, well, mainstream.

Jim and Katharine had fallen for each other in a big way. Katharine was a painter, not a singer. Before meeting Jimbo, she had never played an instrument. She did both with Jimbo, and people marveled at her voice. Ken and Don were recruited to sit in at the farmhouse rehearsals. Ken brought Chris P. Everyone agreed that the band was an art project, but pestered Katharine to do one performance at a basement restaurant in Chapel Hill called Henry's Bistro. Word spread. The house was packed, and people freaked out. My friend and co-worker, Lane, called me from the show. I was tending bar and couldn't get out.

"You have to come down here!" he enthused. "This is the greatest fucking thing I've ever seen."

What Lane saw was a spontaneous event, what people in the 60s called a "happening." Dozens of friends and neighbors turned out in their thrift store best, transforming the bland dining room into an underground speakeasy through sheer intent. They sang and danced and drank and acted like it would never end. Good crowd.

Katharine insisted that there would only be one performance and the guys mollified her, but more shows were booked. They started playing around the state to enthusiastic if slightly confused crowds. Everyone in the band still called it an art project, but it was showing clear signs of commercial viability. I'm not sure at what point Katharine

considered herself a professional musician—maybe when we all quit our restaurant jobs—but she always reserved the right to say no. She taught me that the person in a relationship who says no has the power.

Jimbo named the band after an old-fashioned candy available in one of the local quickie marts, one we referred to as the "Stab and Grab." Squirrel Nut Zippers were cheap and chewy, kind of like a Mary Jane. The packaging was anachronistic. The box had lightning bolts on it, and the wax paper around each piece of a Nut Zipper was transparently mass-produced in an appealing way. What difference did it make where the name came from anyway? It wasn't as if we were going to be famous.

Local label Merge Records, run by Mac and Laura from Superchunk, put out the first Zippers EP in December of 1993. It was called *Roasted Right*, and everyone was, more or less. Katharine designed the record sleeve with one of her collages. In it, a full-color, four-armed hula dancer in a grass skirt advances in front of a black-and-white bamboo boat filled with what looks to be refugees. The procession is just making land.

Roasted Right is the early Squirrel Nut Zippers in a nutshell. Jimbo and Katharine's early, delirious love is described in "You Are My Radio."

Two other songs would be reworked for the first album.

It was an acoustic, string-band effort, charming and quickly done.

Don Raleigh wrote the Squirrel Brand Company and asked permission to use the name. It was a nice gesture: They would never have heard the EP, we were sure. Don included the record with his letter. He talked about how much the band enjoyed the candy. The old man who owned the company wrote back. He told Don that they liked the music and had no problem with the band using the name. The Squirrel Brand's letterhead looked ancient. The design at the top was an engraving, maybe of a building or a squirrel. It recalled a much more gentile time of gooseneck office lamps and manual typewriters.

In December, my band What Peggy Wants had played our last show. I had been playing music with John, the lead singer, since I was twenty-one. At twenty-eight, I thought I had aged out of rock and roll. It seemed much too advanced an age. I was chafing at the bit. I was writing songs that were more jazz than rock, and had said about all there was to say on the drum kit. I needed to move on. I can name this now for what it is: a quarter-life crisis. It may not have the finality of a mid-life crisis, but it is the time when some rock stars drop dead and other people make precipitous life decisions—like getting married or committing to a musical life.

A month after the EP was released, Jimbo got to the door before me at the end of practice. He turned to face me before I got to the door.

"What do you want to be in *my* band?" he asked, with an anxious look.

It was an oddly worded question, and stays with me still. It sounded like a proposition of sorts. What did I want in return for joining Jimbo's band? That wasn't how my mind worked. All my previous bands were extended family. We didn't make interpersonal transactions, or have this sense of propriety. I paused for a moment. "Well, I want to contribute songs and would like to bring Stacy Guess in on trumpet."

Stacy was angularly handsome, a quiet man and a gifted artist. His trumpet tone was melodic and conversational, more like Chet Baker's 50s recordings than the rambunctious Louis Armstrong from the 30s. After my rock band broke up in 1993, I asked Stacy to play with The Minor Drag. We'd practiced a few times before. If I was going to join the Zippers, I thought it best to bring Stacy with me.

Jimbo agreed. Ken, Don, and Chris P said nothing. I'm not sure they were expecting Jimbo to ask the question either. It didn't appear to be a group decision, and Katharine wasn't even there. An odd and soon-to-be-familiar tension appeared. Excited and uncomfortable, I drove back to

Pittsboro and told Mel. She glowered at me. "Why would you do that?" she asked.

In addition to making music, Jimbo drew strange pictures and made marionettes. Around this time I directed a short film, *The Invisible Hand*, using Jimbo's puppets and Fats Waller pipe organ music as the soundtrack. Norwood Cheek was the director of photography. I remember him using a skateboard as a camera dolly, pushing it down the strange little set. In the movie, Mr. Snooty, a sad-faced character, wakes up and walks into his living room. The furniture dances to the music. There is a picture of Fats on the wall, which Katharine animated. Mr. Snooty watches in fascination, before being pursued by demons and sharp objects. Cowering in his bedroom, he is hauled up by his puppet master and devoured. The last image is of Jimbo, wearing a devil mask, with Mr. Snooty's kicking legs sticking out of his mouth. John Ensslin, also a painter, drew the credits that appeared in a book, whose pages turn without hands. Mel helped with costumes and set design, but Jimbo didn't want to give her credit, and we fought about it. Mel was hurt and I couldn't understand why Jimbo didn't want to acknowledge her contribution.

Mel wanted me to stick with The Minor Drag. "You should do your own thing," she said. Part of me agreed with her. I also knew that the Zippers had gotten a head

start and already had a cult following. Even though I had been writing that kind of material for a couple years, people might consider what I was doing a rip-off. It would be a good fit, I argued. Both of us were right. I joined the band and immediately bought black tails at a second-hand store in Pittsboro called Beggars and Choosers. It was late January 1994.

I came into the Zippers as a drummer, taking Ken's seat and freeing him up for guitar. I also played the occasional rhythm guitar, trying to sound like Fats Waller's guitarist Al Casey. Chris P played the contraption kit. Don hunched behind his big stand-up bass, Jimbo strapped on an old hollow-body electric guitar, Stacy growled and lilted on trumpet, and Katharine strummed a four-string tenor banjo. It was all held together with tape and bailing wire.

I brought three songs into the band: the two I had written with John Ensslin that would work, "Club Limbo" and "Plenty More," as well as a cover called "I've Found a New Baby."

Clarence Williams wrote "I've Found a New Baby" in 1919. I know because the Fake Book told me so. Django Reinhardt recorded the first version I heard as an instrumental in 1934. The song is in a major key, but concentrates on the darker relative minor. The lyric is celebratory but not very good. The music is menacing. I made "I've

Found a New Baby" a kind of compositional blueprint.

The song was a prototype of another kind. As I collected old jazz records, I noticed a style of music that had no apparent name. It mostly came from the East Coast, predominately from New York, between the mid-20s and late 30s. These tunes were up-tempo, in a minor key, and rocked like hell. Duke Ellington called the style Jungle Music, a variant on Race Music. Cab Calloway's take on it was his big hit, "Minnie the Moocher," as well as versions of "I'll Be Glad When You're Dead, You Rascal You" and "St. James Infirmary." Fats Waller jumped in with a harrowing pipe organ version of "Beale St Blues"—complete with a bass foot pedal solo—as well as "The Minor Drag" and "Viper's Drag." Many bands performed this kind of music, and I couldn't get enough. It's a kind of gleeful perdition, a threat communicated with a smile.

Something happened when jazz moved up to Chicago from New Orleans, but it was still largely jubilant and in a major key. Things really changed by the time it got to the major population centers on the East Coast. I never knew what this music was called. For lack of a better term, I call it Hot Music. Any musician playing well was said to be playing hot. When jazz gave way to rock and roll as America's popular music in the mid-50s, Hot Music was forgotten. The Squirrel Nut Zippers were only

too happy to help resurrect it.

On the road, the Zippers were phenomenally popular. We weren't great players, but had tons of energy and enthusiasm. Our songs were quirky and catchy, and people swooned over Katherine's voice. We sounded happy, creepy, and unselfconscious. There was nothing like it anywhere, which is a hallmark of a good Chapel Hill band. The first show I played as a Zipper sold out the venerable Cat's Cradle. None of us were used to playing for capacity crowds. We were on to something.

From Chapel Hill, we branched out, playing around the state, then the region. The reception was almost always the same. We took wedding gigs to make ends meet. We got a fairly new fifteen-passenger van for not too much money. This was because it stank of mold under the carpet in the back. We stuffed it with seven people, a full drum kit, a stand-up bass, three guitars with their amps, a banjo, a trumpet, and everyone's luggage. It was cramped. Few things are more lonesome than lying prostrate in the back-bench of the van, pasty and sweating with the flu. We all ended up there at one point or another. Still, our fortunes were made: we only had to play a town once in order to sell out a show the next time through.

One day in early 1994 I got a call from Ken. "There's been a development," he told me. "You'll hear about it at

practice tonight." I was a little unnerved. In the early days, people who played with the Zippers kind of came and went.

"What is it?" I asked. "Is it good news?"

Ken chuckled. "Well, it's good news for you," he said.

At practice that night, Jim and Katharine told me they wanted me to sing. I must admit they didn't have a good reason. I only sang the occasional harmony vocal in What Peggy Wants and had never fronted a band. My voice is much better now, but I've always considered myself a vocalist, not a singer. The Zippers already had two lead vocalists and now we had a third. I was touched by Jim and Katharine's confidence in me and still am.

Chapel Hill's Merge Records, who put out the EP, wanted to sign the band. So did Mammoth Records, based next door in Carrboro. The people at Merge were great. They were musicians who offered 50/50 deals. They are also, I might add, quite successful and still in business. In 1994, however, they were very much an indie label with little money and poor distribution. Ken wanted to know if his aunt, who lived in the Midwest, would be able to buy a Squirrel Nut Zippers record if it came out on Merge. The answer was no.

Mammoth records was also underground, but had higher aspirations. They had a parent deal with Atlantic Records, who had signed Aretha Franklin and Led

Zeppelin. They had more than five people working there. We went with them and signed a recording agreement, much of which we didn't understand. We also signed a publishing agreement—or no deal—which we understood less. The bottom line was that those of us who wrote songs— Jimbo, Kenny, and me—signed away half of everything. The whole band split up the publishing advances.

Amongst ourselves, we signed a partnership agreement. In addition to agreeing to make group decisions and split publishing money, the document gave the name Squirrel Nut Zippers to Jim and Katharine.

We recorded our first full-length album, *The Inevitable*, in October 1994. My memory of the sessions is fragmentary. Bourbon was involved. I remember Chris P's brother, Mike, bringing in his old baritone saxophone and Ken playing it. This was very exciting to me, because Cab Calloway's Cotton Club band had a pretty hot bari sax player. I remember playing drums on some of the songs, "stirring the soup" with brushes to "I Wished for You."

My favorite track on the record and my favorite Zippers' song to this day is "Wash Jones." Jimbo definitely channeled his Mississippi Delta energy into this strange number. Ken and I overdubbed background vocals on the song. He found a plastic toy microphone with a rubber band inside to give it a spooky echo, and we sang through it

into a real microphone. For dramatic effect, Ken whacked a metal space heater with a drumstick.

Ken's songwriting contribution was typically oddball. "Danny Diamond" was about a high school friend of Ken's in St Louis who went on to win the Miss Illinois Drag Queen Pageant. Great lyrics, sung over a slow-burn cabaret number. I really loved this band.

In later years, with equal conviction, people would say all kinds of contradictory things about who we were. Some thought we were underground heroes. Others thought we were terminally ironic. We knew who we were. We were weirdoes, each with a specific role. None of us could notate music, and seldom told each other what to play. Arrangements were left up to the individuals. If we wanted to hear a certain instrument on a song, we learned it ourselves. We played for the joy of it and to make each other laugh. In those days we laughed a lot.

Our touring base broadened that year, with trips to the Midwest and West Coast. In the Deep South, I made a few musical pilgrimages. Memphis was Mecca. Ken and I visited Sun Studios, where Elvis made his debut recordings. I stood in the little main recording room and thought of Howlin' Wolf, who also made records there in the early 50s. In the gift shop, I bought a picture of Johnny Ace.

Johnny Ace had one of the most artistically self-contained careers in music history, mostly because he shot himself backstage during a Christmas Eve concert in Houston in 1954, after recording only twenty-two songs. There's something deeply strange about Johnny Ace's music. It's sad and emotionally remote. Everyone is out of tune. The ballad tempos are funereal. I love it so much.

I remembered what North Carolina musical luminary Mitch Easter told me about Sun Records. In the late 70s, he and some high school pals made another such road trip to Memphis to meet Big Star. The great pop band had already broken up, but Mitch met singer and songwriter Alex Chilton. Together, they broke into the old Sun Studios building, which by that time was a foreign car repair shop, and stole a ceiling tile.

We would have gone to Stax/Volt studios, where my favorite 60s soul records were made, but it had been torn down years ago. I told Ken we needed to visit Ardent Studios, where Big Star recorded. I had heard that the band's drummer, Jody Stephens, worked there. The cabby knew where it was and dropped us off. We didn't even make any pretense of wanting to book a session—like we did years later at Abbey Road, where the Beatles recorded—we just asked the secretary at the front desk if Jody was there. "He'll be right out," she said.

A few moments later he came around the corner, affable and lanky. My mind raced back to the mid-80s, when a friend introduced me to Big Star by playing *Radio City*. "You'll like this drummer," he said, and I did. I memorized all their records, once I managed to get my hands on them.

We introduced ourselves, and fell silent. "We love Big Star," I mumbled, "and think you're great." We didn't really have a game plan.

"Thanks," he said. "Would you guys like some carrot cake?"

Then we were in the lounge, with carrot cake and coffee, talking to Jody Stephens about drumming. He showed us the wood-paneled room where Big Star's last album, *Sister Lovers*, was recorded. I asked Jody how many copies of their first album, *#1 Record*, they sold and was told only a few thousand.

"Jesus," I said. "That's not enough to quit your day job." *The Inevitable* had already sold more copies.

"Oh, I never did."

Back in the lounge, I asked about Johnny Ace. Jody said he didn't know much about him, but Jim Dickinson would, and gave me his number. A minute later I was on the phone with the man himself—the musician and producer of the Rolling Stones, Big Star, and so many others—having the coolest discussion about the slap-back echo on

Elvis's voice on those Sun sides, and whether it was done with tape delay. Dickinson told me where to go to see a picture of Ace sitting in with the Beale Streeters, Ace's band in Memphis, and said he would give me a picture of Johnny in his coffin. Jimbo somehow managed to intercept it, but I saw it later in a book.

In Houston, I met a guy who told me the Civic Auditorium, where Johnny Ace died, still existed. I stuffed a couple beers in my coat and we drove downtown. We walked in, and found several construction workers inside. No one seemed to notice us, although I had made up a story to cover our intrusion. We found two identical, cramped dressing rooms on either side of the stage. One felt right and we opened our beers, toasted Johnny Ace, and drank. Weeks later, my Houston friend faxed me the police and coroner's reports from that Christmas night.

In 2010, after the deaths of original Big Star members Alex Chilton and Andy Hummel, Jody Stephens came to Chapel Hill to perform a tribute show. I met him in the Cat's Cradle parking lot and gave him a slice of carrot cake. I reminded him of his generosity, and we chatted for a moment about a hard year. Then I left to play my gig while he played his.

As we toured the country, I continued to make such pilgrimages. Three years later, on a boiling summer's day in

Camden, New Jersey, I decided to leave the air-conditioned bus to walk into town. I wanted to find the old Trinity Church where Fats Waller recorded his pipe organ sides in the 1920s. I told the theater employee on the landing dock about my plan. He looked at me. "Walking into Camden is suicide," he said. I felt foolish. What did I expect to find? If the building was even there, and if I looked through the stained glass at just the right angle, would I see the shadow of a young man, working that ancient Estey organ with his hands and feet?

It was because Fats Waller was alive to me. His recordings were living things. The music he showed me, and his enthusiasm in making it, became part of who I was—who I am. This is what musicians do. We internalize our influences. They live on through us, however imperfect a vessel we may be.

In 1995 we toured the West Coast for the first time. I think they were more ready for us than we were for them. San Francisco was wide open. After sound check at the Café Du Nord, a high school friend met me for dinner. "I'm waiting on somebody," she said. "She's going to meet us here." I asked for her friend's description, so I could be on the lookout. A beautiful young woman sat way across the room. I glanced at her. "Is that your buddy?" My friend

looked. "No." The young woman, who had been staring at us, walked right over. She was stunning. "Hello," she said, in a very friendly voice. We told her that we were sorry, but we were looking for someone else. There was a pause, as she regarded each of us. "Okay," she said, and left. I looked at my friend in amazement. Where I was from, beautiful women didn't walk across the room for no reason.

"Oh, that's just San Francisco," she laughed. "You never know who they're hitting on!"

I bought a blue, ankle-length outfit in Chinatown. As I paid for it, I asked the woman what it was called. "Oh, it's a 藍色長袍" she said. "A 藍色長袍," I repeated. Cool. I needed to remember that. I was the kind of guy who knew what these things were called. Truth be told, that name fell out of my head as soon as I hit the sidewalk. Like I was going to remember *that*. I wear it on the back cover of *Hot*, the soles of my bare feet just touching the pool water.

We played that night to a packed house. Everyone knew the lyrics to *The Inevitable*, and we had never even seen that town before. The small room heated up quickly, and the crowd pressed in, singing:

So if you lose the one you love
There's always plenty more

Of all the shows we had played, ever, this one was the best. There was never a more engaged, enthusiastic crowd. We were delighted, of course, but completely taken aback.

In LA we were assured we had a great "buzz," but the crowds kept a curious distance. (I just remember frowning models, standing beside SUVs, talking on gigantic cell phones.) In San Francisco, we were mobbed. I didn't quite understand what was going on, but it felt big. It was the start of a golden moment, before the "swing" boat anchor was hung around our necks. Most of the interview questions were still about our name, as well as some lingering, perfunctory attempts to still categorize us as "lounge." But for a little while yet, we were underground. People dressed as they wanted to look, not as style dictated. They danced like Lindy Hoppers, hippies, and spastics. It was wonderful.

Months later, after a show in Chicago, a woman approached me. "That's a stunning blue Chinese outfit," she said. "What's it called? You look like the kind of person who would remember that."

That summer, Jimbo asked Kenny and me if we wanted to go to New Orleans. I'd never been. It felt like a very important thing to do, even though we had no obvious business there. I didn't know how to explain it to Mel, but

she understood anyway. We left in Jimbo's shitty car and deadheaded to Louisiana.

Twelve hours later, we pulled in front of Glen Graham's house. A friendly, bearded guy, Glen was a high school friend of Jimbo's, and the drummer for Blind Melon. Inside, I noticed the quadruple-platinum award on his wall. It was also clear that he had pulled the doorbell wires out of the frame.

There was a studio in Glen's basement where we messed around that night. That's where we met Mike Napolitano, who we called Nappy. He was skinny, always wore cowboy boots, jeans, and a v-neck t-shirt, and had long curly black hair. He watched our drunken jam session for a few minutes, and began proficiently setting up microphones. He was easy to get along with, spoke with a New Orleans accent ("all my friends are strippahs"), and wasn't fazed by lunatics, alcoholism, or technical problems.

Mike had been an assistant engineer on Blind Melon's latest album, recorded in Kingsway Studios. Glen took us there, and we marveled. It was a perfect place to make an album.

Back at his house, Glen appointed himself our tour guide for the evening. He sat us down. "There are basically three parts of town," he said, drawing a map on a piece of paper on a coffee table cleared of beer cans. "Here's

the touristy part—Bourbon Street—which is boring. Over here is the part where you'll get killed, and this is the part in between. That's where we're going."

That night, he took us to a club in Tremé. I was a little nervous but we were made welcome. The crowd was there to see a brass band—either the New Birth or the Rebirth; I don't remember which.

The band walked into the club playing, followed by the crowd they had gathered in the neighborhood. There were two or three trumpets, the same number of saxophones, a trombone or two, a sousaphone, and marching bass and snare drum. One of the trumpet players was a skinny high school kid. *Oh, how sweet,* I thought. *They let the youngsters play along.*

The band didn't play a set. They just played. One piece folded into another. The drummers produced this loose-limbed beat, funky as hell. It's not possible for one musician to play anything like that on a drum kit. The sousaphone would occasionally emit shrieking blasts. Guys soloed when they felt like it, overblowing their horn. Pitch was not a concern.

Then the skinny kid pointed his trumpet to the ceiling and blew like a hurricane. He was the best player of the bunch.

By this time we'd had a few glasses of some bright blue

drink and were dancing with everybody else. We were possessed. The band finished their first set by marching out of the club and around the block. Everyone followed. It was a clear summer night. The moon was pinned to the sky like a badge. Music bounced off the houses and rattled around our ears.

One big black girl leaped in the air, straddled a concrete stoop, and twerked. Her ass shook so hard and fast I thought it would detach. We danced like fiends around the block and back into the club. The band headed to the bar. I screamed until I lost my voice. It was all a dream.

The Squirrel Nut Zippers had found their community. In New Orleans, music isn't separate from anything. It can't be contained in a club, or limited to a certain emotional ritual. It doesn't exist apart from the past or in opposition to the present.

From New Orleans we drove up to Jimbo's hometown of Clarksdale, Mississippi. I took Ken to see nearby Starkville, where my family had settled for a hundred and fifty years. On the way we stopped to get snacks. The young black girl at the gas station register stared at us for several seconds. Ken was wearing a short-sleeve blue plaid shirt and cutoff overalls. I sported a pink camp collar shirt and lemon-yellow Bermuda shorts.

She regarded us with amusement and disdain, and then

rendered her verdict: "Y'all from Mayberry."

In the summer of 1995 we played the Black Mountain Music Festival and met Andrew Bird, a young, handsome violinist. He was from Chicago, playing with an Irish fiddle band. He took a shine to us immediately, and we recognized his talent. I decided to test his knowledge of old jazz. "Do you like Eddie South?" I asked him. Most violinists have heard of Stephane Grappelli, who played with Django Reinhardt, but Eddie South was more obscure. Andrew said that he had.

The next morning, after seeing us perform, Andrew came up to me. "I had a dream that I was supposed to play with you guys," he said in his awkward, slightly distant way.

"Ok," I said. I wasn't sure if this was a good sign or not. Besides, I was stoned. "Have you heard of Eddie South?" I asked.

I may have been baked, but I was also distracted. Stacy Guess hadn't shown up to the festival at all. We went on the first night without him. We expected the worst.

Ken and I knew Stacy was doing heroin again. As the Zippers toured more heavily, his behavior became erratic. One night we played a basement club in Boston during a torrential downpour. The ceiling was being held up with two-by-fours. After the show, Ken scored some pot from

a severe-looking woman. We went back to the townhouse where we were staying. The power was out. Stacy was in the house with us, but wasn't hanging out. Ken went to pee and found Stacy in the bathroom shooting up. Ken came back to his seat in front of the picture window, visibly shaken, and told me. We sat in confused silence. "What do we do?" I whispered.

Stacy approached us. "Look," he said. "This is between us. There's no difference between what I do and you guys being stoned all the time. I don't want you to say anything to anybody." He talked in the dark, occasionally lit by flashes of lightning.

I didn't agree with him, but was cowed. I see us there in that room now, so young, engaged in an emotional stand-off. Later, I would have smacked that shit out of his hand and flushed it down the toiled, demanding that he grow the fuck up. Now I just regard the scene with a helpless kind of sadness. As a young man, I was open to experiences that I have insulated myself from now. As an older man, I know that redemption, when it happens, is all the more miraculous because it's so rare. But it was so dark in that room. There was so much that couldn't be seen, that that had to be inferred. Any illumination was brief, and harsh. Kenny and I kept that secret, and it harmed us.

Once Stacy started missing shows, we told him to take

time off and get cleaned up. We figured that the possibility of losing his position in the Zippers would motivate him. Stacy never returned to the band. He died in Chapel Hill of an overdose in March of 1998 as we were touring Europe for the first time. Mel called with the news: first that Stacy had been brought into the hospital, then, a day or two later, that he was dead. When I told the band before sound check in Germany, no one really said a word. By that time we were too emotionally distant to even share grief.

We asked Stacy to leave two weeks before the sessions for our second album. In September 1995, we flew up to Chicago without a trumpet player.

Ken had to take up some slack as a soloist. He decided the laundry room of the hotel was the best place to practice scales on his alto sax. I left him there when I went out to scout the neighborhood and buy presents for Mel. I returned to our room and was fumbling for my key when a bald man burst from the door, grinning demonically.

"EXCUSE ME, CAN YOU TELL ME WHERE THE BALL POLISHER IS AT?" he yelled. I looked in horror at this stranger with cuts on his head. It took a couple seconds to recognize Ken's voice. He had shaved his head with a disposable razor. He looked insane. We both laughed about it but I decided that Ken had, in fact, gone a little insane.

As luck would have it, Andrew Bird lived in Chicago.

He learned six of our songs during sound check, and played another four or five onstage without having heard them at all. We asked him to join us in New Orleans for the recording session. Ken pulled a lot of weight that night too, and continued to improve as we bounced around the Midwest.

Our new booking agent, Erik Selz, had set up a strange run. We played Chicago one night, St. Louis the next, and then back to Chicago. We had to drive something like four hundred miles in each direction.

I didn't have a good first impression of Erik. We first met him in a club in Chicago. He sat at the bar and as we entered said, "Is this *my* band?" It rubbed me the wrong way. I noticed it a lot more when we were famous. People want to own you. We didn't belong to anybody, as far as I was concerned. We belonged to each other.

Selz was a bulldog, and got us good guarantees. He also ruffled feathers. We'd get complaints from some club owners, but decided in the whole it was better to have someone on the job that was getting us good deals.

We didn't quite know this yet, though. What we knew was that it's a long drive from Chicago to Washington University in St. Louis. After sound check, we all played some hacky sack. I've never been a physical person, and hacky sack is especially ridiculous, but I suppose we had to kill time without the presence of a drinking establishment.

Chris P and I went for the sack at the same time and collided. The top of his head hit me square under the eye, giving me an impressive shiner.

We played well for a small crowd. Beatle Bob was there. He was a middle-aged skinny guy with a black mop-top haircut. He danced like he was digging potatoes for God.

"Ooh, Beatle Bob's here," someone said. "That means you're really cool. He only goes to the cool shows."

Afterward the nice student liaison apologized and told us there was a mix-up and we couldn't get paid until the next day. That's fine, we said. Just put it in the mail. Right before we left, Ken had a flash of inspiration. He went to a pay phone and called his high school buddy Ed Lott.

As we drove back to Chicago, Ed called Erik Selz pretending to be a school administrator.

"I just need to know who's going to pay for damages," he said.

"What damages?" asked Selz.

Ed did as Ken directed and spun a yarn about the Zippers showing up drunk. He told Selz that we beat up the soundman, and the guy was only a student. During the conversation, Selz put Ed on hold a number of times because it was clear to Ed he was hyperventilating. The hold times kept getting longer, giving Ed time to think up some new outrage.

In a panic, Erik called the student liaison. "Did the band get paid last night?" he asked.

"No," she said. "There was a problem." Before she could elaborate, Selz blurted out "I'll call you back!" and hung up.

When we got to the venue in Chicago we told Jim and Katharine about the joke. They laughed. Soon Erik came storming into the club. "I need to talk to you guys about something important," he said. We told him to wait. Andrew Bird was there and needed to learn some songs. This was true, but still we took our sweet time. Erik finally burst into the dressing room.

Luckily for us, the dressing room hadn't been cleaned from the previous night's performance and was filled with empty beer bottles. Ken pretended to be drunk and walked into a folding table, loudly knocking bottles on the floor. "*Fuck*!" he said, a little too loudly.

Selz sat down. "I've been getting some disturbing phone calls," he said. "Either you guys are the rudest motherfuckers on the planet, or somebody's playing a brilliant practical joke. I need to find out which is happening."

We were cagey, and strung him along for quite some time. Damages? What damages? Erik pointed to my black eye.

"Is there something you want to tell me?" he asked.

"Look," I said. "I admit things might have gotten a

little out of hand, but you need to understand that I was more tired than drunk."

This could have gone on the whole night, but Katharine blurted out that it was all a joke. It was as if she didn't want to go to detention with the rest of us. Erik laughed at his own expense, and we all roared when he mentioned calling the student liaison.

This was the beginning of our alternate career as performance artists, at least for Kenny, Chris P, and me. We each had a little bit of a mean streak that lent itself to such friendly abuses. It took a certain skillset, like the ability to read your victim and how much reality to work into your sham.

We played a great one on Richard Gilewitz, another musician we met at the Black Mountain Music Festival. Richard plays finger style folk guitar like the great Leo Kotke. He doesn't sing, but tells hilarious stories between songs. Kenny and I buddied up with him. I thought *we* were nuts, but Richard toured around the country by himself, which has got to affect your brain.

The next year, we played with Richard in his home state of Florida. He agreed to come back to our hotel to hang out after the show. He would arrive later, as he had to go home and get his dog. When we arrived at the hotel, I knew instantly what needed to be done.

Chris P, Ken, the merchandise guy, Chris Tousey, and I prepared the room. Ken turned the heat up all the way. I ran the hot shower tap until the place was so humid you could see your footprints in the carpet. Tousey scattered a few condom packages around by the television. Chris P emptied all of the merch money—several hundred dollars in cash—on the bed. All of the lights were turned off except a lamp. We covered its shade with my pink camp collar shirt. Then we all stripped naked, shoved our clothes under the bed and dealt ourselves a hand of poker.

I'll never forget the minutes that passed before Richard came. We were giggling because it was funny and because it was uncomfortable. I didn't want to, but couldn't stop staring at Chris P's patch of bright red pubic hair. Still, though—we knew our role. Richard had to believe that this was our nightly after-show ritual. We also decided that, for the joke to be a success, he had to come into the room and play a hand.

We heard the scrape and click of dog feet on the stairs. There was a knock on the door. Ken got up and answered in all his glory. I found myself looking at his little butt.

"Hi," he said in a friendly voice. "You're just in time!"

"Oh my god." Richard jumped back a foot.

"Want to play some poker?" Chris P asked nonchalantly.

"No, it's cool. You guys have your own thing going on.

I should probably go home."

This went on for some minutes. And then the magic happened. Richard actually came in, sat on the bed, and played a hand. We lent him some money from our pile of cash. I even remember him asking which card was wild. When he lost, we all collapsed in laughter, pulled our clothes out from under the bed and revealed the joke.

I don't think he ever believed us. His dog, though, didn't care.

Ken's belief is that these jokes brought us together. I think that it was a way to relieve the boredom. We exercised some control by manipulating our own image. The Zippers were just strange enough for Richard Gilewitz to believe that naked sauna poker parties were routine, and exuberant enough for Erik Selz to think we walked into clubs drunk and picked fights. If you have a certain persona onstage that is only an aspect of you, why not create one for other parts of the day?

In October of 1995, we had a bald saxophonist and no trumpet player, and had convinced the label to let us record in a studio we couldn't afford with an engineer we'd never worked with. It was time to make the biggest album of our career.

CHAPTER TWO

PUT A LID ON IT

OF THE ENORMOUS FRENCH QUARTER MANSION ON
Esplanade Avenue in New Orleans. We made good time
because Ken was speeding. Karen Brady, Kingsway Stu-
dios' house manager, came out to help us load in.

I stepped out of the van and looked up at the veranda's
iron railing. "What's the name of your spook?" I asked,

hoping to have guessed correctly.

Karen stopped smiling. "Who told you about that?" She looked as if ghosts were bad for business.

The Kingsway vibe was perfect: a 12,000 square foot New Orleans house, gilded, tiled and filled with vintage recording gear. Out back was a rock-lined swimming pool and big tropical plants. Inside, the ceilings were at least thirteen feet high. The wood floors were covered in raggedy, expensive Moroccan rugs. Marble-topped tables held Tiffany lamps. There were rooms upstairs where we could sleep. The label consented to let us book a week. It was late October 1995.

The Arnaud family, founders of the famous French Quarter restaurant of the same name, built the house in the 1860s. Now it was owned by Daniel Lanois, whose reputation had been made producing U2 in the 80s.

Karen said Kingsway had an active spirit, believed to be Germaine Cazenave Wells, former owner of the house and daughter of "Count" Arnaud, the restaurant's founder. A dedicated drunk, Germaine died after falling and hitting her head. By all accounts, she continued partying anyway.

After I assured Karen I didn't mind the place being haunted, she eased up. But I would learn why she'd been concerned: not all of the musicians' experiences in the studio had been positive. A bass player (who was also an EMT)

was awakened one night by a severely burned girl sitting on his bed, begging him for help. He asked the next morning who she was and why she wasn't in the hospital. When told that she was an apparition of Germaine's daughter, who had been injured in a house fire some decades ago, he packed up, said "I can't hang with that shit," and left.

Ghost or no ghost, we had a record to do. There was a disagreement about our production approach and we lost a couple days. I wanted to do the record live with just a few microphones. We only had six days, I reasoned, and besides, all our musical heroes had recorded live. There was no overdubbing in the 1930s. Multi-tracking was impossible. People recorded to acetate discs or straight to reel-to-reel tape. Bands knew how to play live and not drown each other out. Instrumentalists knew to lay low under the vocals. Engineers were intimate with their rooms and equipment. They knew where to place the band and the mics. There was no such thing as "bleed," the term for one instrument coming into another's mic. It was called balance. Nappy understood this immediately, but wasn't producing the session.

The test song for the Zippers attempt at recording live was "Put a Lid on It." We were all in the same room. I stood on a piano bench behind Katharine so her microphone would pick up my background vocals and acoustic

guitar. Chris P played with brushes. We only used four mics for that song. One take was fabulous, but Chris P wasn't happy because he sped up the tempo. We decided to try the song again another day and the recording-in-one-room approach was abandoned.

Around two a.m., a few of us settled in the upstairs lounge (where Germaine reportedly died) to have a drink before bed. As we decompressed, Ken Mosher went into the adjoining bathroom to relieve himself. It was cramped and tiled floor to ceiling in unpleasant, early-60s pink. It had a bad vibe. Over the toilet was a window that had originally looked out on an alley that Kingsway had expanded into long ago. That alley was now the laundry room, some twenty feet below the pink bathroom's window.

From the bathroom, we heard Ken call, "Are you guys out there?" He sounded weird.

"Um, yeah. We're still out here."

"Wha—what the fuck?" Concern became alarm when Ken emerged. It's cliché, but he was honestly white as a sheet.

"I think I've just seen a ghost."

He told us that as he'd stood at the toilet, looking up absently, a face had appeared in the window. It was like somebody had turned a red light on. A thin, asexual head with a slit mouth glared down at him. Thinking it was a

trick of the light or a practical joke, Ken looked around at the mirror behind him. He looked back at the face, which faded away.

After some excited conversation and several assurances that we weren't pulling a prank, everybody went to bed. Ken and I sat in his room and talked about the experience. He said the face looked like something from *Star Trek*.

We tried to make a Ouija board from notebook paper and a shot glass. I remember it as Ken's idea. He drew sloppy letters on ruled paper, and then we asked timid questions while touching the unmoving glass. I'm glad it didn't work. I love that image, though. Two oddballs in a sumptuous room, huddled over a makeshift apparatus, trying to contact the spirit world after it had made such an overture.

I decided I didn't mind the ghost but didn't want any bullshit. There were no showers, except in the pink bathroom. I would take quick baths in the old claw-foot tub, making deals with Germaine: "I'm cool with you. Please don't come in here when I'm naked."

News of the event spread. Chris P lost no opportunity to make fun of us. He taped a gorilla's face, cut out from a magazine, on the pink bathroom's window.

A night or two later, I poured myself into bed, the worse for drink. I was almost asleep when the bed jumped off the floor. I shot upright. Maybe it was a dream. The bed

lifted up again. I cried out in terror. This brought pealing laughter from under the bed, and Chris P appeared, reeking of alcohol. "I was just having a little fun," he slurred. I gave him some version of "Go to bed, asshole" and finally fell asleep. But I was spooked.

A few days later, I disarmed Chris P by telling him the loving truth. Approaching his drum kit between takes, I looked him straight in the eye and said, "Look, man, I just want you to know you're a fantastic drummer and I love being in a band with you." That really shut him up. He could hardly form a sentence. A more normal exchange occurred the time he laid into me for getting stoned before a take, yelling about my choice of refreshments even though he woke up late and hung over.

My response, after exhaling luxuriously, was, "See you in rehab, motherfucker." Nappy laughed for five minutes.

We finally arrived at a basic recording set-up. Instruments were individually miked, just in case. Beyond that, Kingsway had several rooms to choose from. Where should we put the bass? How do we record vocals with other, louder, instruments? We compromised. Chris P had a room to himself, so he could bash away. As much of a pain as he could be about it, I understood how important his drumming was.

Recording went smoothly. We had been touring these

songs—most of them anyway—for months. We recorded them mostly live, much as we performed them. By the third day, we had established a routine. There was a room for vocals and horns, a room for Don's bass, and a room for quiet instruments, like Katharine's baritone ukulele. We could set up for songs of any arrangement and record them quickly. Once we all were out of bed—except Chris P, who might linger a little longer—we'd walk down to the Kaldi's for some not-very-good New Orleans coffee. On the way we'd see the hardliners propping up the bar in some French Quarter dive. I never knew if they had just gotten there and started drinking before noon, or if they had been there all night. Did it make a difference? Time doesn't quite flow in New Orleans like it does everywhere else. It contracts and expands, or doesn't move at all. If I remember right, one of the guys was dressed like Santa, even though it was just past Halloween.

Later in the day, we'd get supplies from the Verdi Marte. This usually consisted of shrimp and oyster po' boys, beer, ice cream, and smokes that a dude would deliver on his bike. It was heaven, really. We could stay in the studio and work through the day. Most nights were spent at Lafitte's Blacksmith Shop, a haunted bar in the Quarter. We'd watch Johnny the Piano Man sing jazz standards. He was schlocky and wonderful. When you held out a

tip, he would grab it in the jaws of a plastic alligator head. One bright day, walking through the Quarter, we passed a dilapidated old building. It looked like it was about to collapse. "That place should be condemned," I said.

"Dude," said Nappy. "That's Lafitte's." We went in for a drink.

Five days later the album was mostly tracked. I had done my part: the vocals were on "Hell," we had broken some things, and I had told Chris P I'd see him in rehab. But there was no trumpet on the record. Based on a recommendation, we hired Duke Heitger—even though no one had ever heard him, let alone met him. Ken and I were walking back to the studio after buying a bottle of bourbon on the last day, to be used either for celebration or consolation.

"Excuse me, are you guys in the Squirrel Nut Zippers?" asked a voice behind us. We looked around and saw a cherubic-faced man, holding an instrument case. "I'm Duke, your trumpet player," he said. We ushered him in.

"I hope you know what you're doing!" said Ken, laughing.

Duke took out his trumpet and warmed up on the couch by the mixing board. Jimbo, Ken, and I sat around him, hoping for the best. We heard a loud, clear tone as he ran scales. Once, a little air leaked out between Duke's

lips and his mouthpiece and hit Jimbo forcefully on the cheek. We knew we had the right man, so we upended the bottle of bourbon. Duke could not only play like Louis Armstrong, but also could growl and use the plunger mute like Ellington's great trumpeter, Bubber Miley. I found this out when I dropped Miley's name as a reference to Duke, as I had mentioned Eddie South to Andrew Bird.

James "Bubber" Miley is a guy who never got his due. For starters, he was one of the few trumpeters in the 1920s who didn't copy Armstrong. "Pops" had a broad, open and melodic tone. Joy came out of his horn. Bubber didn't grow up in New Orleans. His jazz was different. He used a plunger mute, making *wah-wah* sounds, and got distortion by making a buzzing sound with his lip. The combination of these things was called "growling." In this sense, had there been no Bubber Miley, there would be no Jimi Hendrix, with his distortion and wah-wah pedals. Bubber was the architect of the hot music I love. Duke Ellington said that when he heard Bubber play, he "forgot all about the sweet stuff." Bubber co-wrote a number of early Ellington pieces, like "The Mooche" and "East St. Louis Toodle-oo." Still, he was a drunk and unreliable, and Duke got rid of him. When he died of tuberculosis at the age of twenty-nine, few attended his funeral. I saw a picture of Bubber Miley once, in Duke's band in the mid-20s. He stares at

you, and unlike everybody else, looks dropped into the shot from the present day. Being able to mention his name to Duke Heitger, and have him respond on the horn, was the most satisfying kind of musical shorthand.

Duke cut all his parts in a few hours. We paid him dearly because of union scales, but at the same time we'd never heard playing like that. The best guy we could have found put the most important lead instrument on *Hot*.

By this time I had followed Ken's example and was playing the saxophone again, although I didn't feel the need to either shave my head or learn my scales. I was especially excited about the baritone sax, a big beast with a looped neck and punchy, low tone. I took it for a spin on Jimbo's "Bad Businessman," thinking about that cat in Calloway's Cotton Club Orchestra. With Ken on alto sax, we were able to fill out the horn arrangements, but the lead instrumental voice in the Zippers, as well as nearly all the bands we emulated, was the trumpet.

It was a shock to lose Stacy Guess as our trumpet player, especially under the circumstances, but his style never quite fit. It's not that he didn't have a great tone or sense of melody. It's more that he played like Chet Baker, maybe the finest example of smooth West Coast jazz from the 1950s. Chet did not play hot. He was decidedly cool. There was no need to blow the roof off like the old school guys did. Chet

stuck to the melody, and was also a fantastically talented vocalist, but everything he played was more introspective and softer. He was also, I'm sorry to say, a smack head that lived far longer than he should have. Musically, at least, he was a big influence on Stacy, who could growl, but didn't listen to Bubber Miley or Armstrong. Duke Heitger knew these guys cold.

We asked Duke to join the band. Although it wasn't the most attractive offer—Look, you get to tour in a moldy van with six lunatics!—we had an ace up our sleeve. It was the partnership agreement, and we were willing to extend that offer to Duke. He didn't have to be a sideman. He could be one of us.

"Aw, I like you guys," he said, "but I have a good thing here. I don't have to tour, and I have my regular steamboat gig and session work." It was true. Duke had dialed it in. He was a stay-at-home musician, while we slugged it out on the road. He made great money as a session player—as we found out, though he was worth every penny. We were getting better at playing our instruments, Ken and Jimbo especially, but no one was going to hire us as sidemen. I was becoming a great rhythm guitar player, but how much call is there for a session rhythm guitarist? Duke had a cash cow, and all we could offer were some dodgy magic beans. We went home and hired a local boy.

On our last day at Kingsway, we put our bags by the door and listened to the record, top to bottom. Though what we heard that day wasn't in its final order, and one song went away before our very eyes, this was the first time we saw the forest instead of the trees. The *Hot* album revealed itself.

It starts with Jimbo's "Got My Own Thing Now," a joyous manifesto. The first thing you hear is Duke belting out the head riff like Armstrong, then Jimbo tells us where it's at.

Jimbo could express joy in his songs better than me. If we were the bookend writers of the band, then he was Armstrong and I was Bubber Miley. It worked out well, because "Put a Lid on It" follows "Got My Own Thing Now."

"Lid" wrote itself. It came to me in the shower and wouldn't get out of my head. Drove me crazy. I heard Cab Calloway singing it. I borrowed, again, from "I've Found a New Baby," and it was all set.

It's strange that the first person I showed it to was Stacy Guess. It's about him, although you'd never know. I was wrestling with my silence that night in Boston, when Stacy told me to keep my mouth shut about his addiction. It all came out in "Lid" as a call and response with Katharine, as Stacy, stating her case.

Say every time I turn it loose
You cats come down and cook my goose
When I start I just can't stop

"But if you keep this up you're going to blow your top!" Jimbo and I answer. As a song, it's all good fun, but I did want Stacy to stop. I wanted him to see what was happening. I couldn't use conversation, so I did what I always do and used a song. He never knew.

The last verse was about Katharine. I wanted her to sing it, and kind of made a joke at her expense.

Well grab your drinks and clear a space
I think it's time to torch this place
Now the girl's in overdrive. . .

From a rock and roll standpoint, Katharine wasn't going to burn anything down. But she *was* a torch singer.

When we put the songs in order, we front-loaded the record so it came out of the gate furiously. Jimbo's "Memphis Exorcism," an instrumental, followed "Lid" with more ferocity. Then a couple ballads: my song "Twilight" and another anti-love song, Jimbo's "It Ain't You." Jimbo could do the minor-key stuff as well as anybody.

"Hell" is smack in the middle of the album. Even

though it was going to be pressed as a CD, we still thought about Side One and Side Two. "Hell" would have opened Side Two. If nothing else, it shows that we weren't thinking of the song as a single. We weren't thinking about singles at all.

"Meant to Be" follows "Hell." I wrote it to convince Mel to marry me, since her first response was something like "ask again later," like a Magic 8 Ball I had as a kid.

Ken has a couple songs on *Hot* too, and the first one you hear is "Flight of the Passing Fancy." It's jubilant and off-kilter, like Ken. The big thing was Chris P's drum intro. It's straight from drummer Gene Krupa's playbook, best known from Benny Goodman's incredible "Sing, Sing, Sing." You know it when you hear it, a loping, white-boy's approximation of jungle drums. It's iconic. It also became a Swing Revival cliché, which was a drag. We always closed our sets with "Flight," after I blew my wad on "Hell." So many nights I would stagger back to the bari sax, hyperventilating, while Chris P hammered away on his floor tom, bringing in "Flight." Some crowds formed spontaneous conga lines. By the end of my extended sax solo I was ready to faint. This was when you could smoke on stage. I used to put my cigarette up near the horn's octave key and blow my brains out, looking at the crowd through the thin trail of rising smoke.

We recorded *Hot* on 2-inch reel-to-reel tape. The old Studer tape machine was controlled by a remote. The remote was about 2½ feet high, on wheels. From there you could put any track into record by flipping a toggle switch two clicks over from "play" (green light) through "safety" (amber light) into "record" (red light). The last track on the master comp reel was "The Interlocutor." Before the song was finished, the music went away. I looked up from the couch and all twenty-four tracks on the remote were lit up red. Our song was being erased! Nappy punched at the console several times and finally got the tape stopped, but the song had a three second gap. We never listened to the Kingsway version again. Somewhere in the record company vaults is a reel-to-reel tape with "The Interlocutor" on it, partially erased and never mixed. I've always wanted to put those reels up and listen. In a recent conversation, Nappy told me he believes it was a mechanical malfunction. Imagine that: a recording device that, when it fucks up, can erase entire songs.

I talked to Trina Shoemaker about this incident as well. At the time she was Kingsway's house engineer, having just worked on Sheryl Crow's eponymous album. She is one of the best producers around and went on to win a couple Grammys. Trina told me that the tape machine remote did in fact have a "record all" switch. However, once this was

activated, every track would blink green, alerting the engineer to all-track recording standby mode. A person would then have to deliberately push the play and record buttons to begin tracking, and the lights would then turn red.

Nappy told me he was standing three feet away from the remote unit. It's possible, I suppose, for him to have bumped it accidentally, flipping the all-record switch. I hadn't seen him, or anybody else, pressing play and record. I prefer to think it was a ghost. Maybe, in those few seconds of silence, Germaine left some kind of commentary.

We re-recorded "The Interlocutor" a short time later in North Carolina, at Mitch Easter's studio in Winston-Salem. (The Interlocutor, for the curious, was the name of one of the stock characters in a minstrel show, a blackface comedy. He was the master of ceremonies, and as Don put it in a song we never recorded, a "low-rent millionaire.") Ken and Jimbo had the flu, and I wasn't feeling too hot myself. The song came out well.

It was decided to remix at Kingsway in January 1996. Ken, Chris P and I drove down.

We met Nappy and headed over to Kingsway. I was glad to be back. The place was magic.

Trina Shoemaker came by to help us get set up. "I'm going to get the tape machine set up for tracking," she said. We told her it wasn't necessary; we were just going to mix.

There was no time to lay down additional instruments or vocals. The record was in the can.

"It's my job, guys," she said. "You might want tambourine on something. It won't take long." We had to admit she was right, and being thorough. She was house engineer, after all. We shut up and let her do it.

I've never been technically minded, but understood that Trina had to align the tape machine using something called a tones reel. It involved recording over the tones, which are sounds of a certain frequency put on tape. As she finished and took the machine out of record, we heard the last few bars of "Put a Lid on It." Trina let fly with a string of impressive obscenities.

"Oh, fuck," said Nappy.

I was on the couch, leafing through a magazine. "What? What is it?"

Trina had accidentally erased the master recording of "Lid." It wasn't her fault; it was on the Tones Reel, and thus destined to be recorded over. On the tape box was written "Tones—No Masters." The song was gone, and irretrievable.

"Well, that's that," I said. It's not like the three of us could have re-recorded it. Trina was inconsolable. She ran into the office and alternated between sobbing and screaming at the producer on the phone. We assured her that she

wasn't to blame, and bought her a bouquet of flowers the next day. Still, we were down a track for an already short album.

In typical fashion, Nappy saved the day. He rummaged through his bag and produced a digital cassette tape called a DAT. He had recorded the entire *Hot* session on DAT, even when we weren't tracking. There, sure enough, was a version of "Lid." Because we had only used four mics, the mix sounded good—miraculously, as Nappy had absent-mindedly pushed up the faders for reference. There was, however, no trumpet on it. We called Duke Heitger. "We're in town," we said. "Wanna go out for drinks?"

After a couple belts, Duke agreed to put down trumpet that weekend. It cost us time-and-a-half union scale, but what else could we do?

A day or two later, Duke was set up in the big room. He did several takes, all of them serviceable, but something was missing. He wasn't playing with any fire in his belly. "What did you think of that one?" he asked, after the fifth or sixth pass.

"Duke," I responded, "I like 'em all. What do *you* think? That's what's important."

Duke sighed. "Aw, man," he said. "I hate everything I do."

"Fuck you," I said. "If I could play like you I'd sit in my

bedroom all day with my trumpet in one hand and my cock in the other. Anyway, we've got the take. Just play whatever you want. Lose your mind. Play like you're drowning." He did, and that's what's on the record.

We mixed *Hot* like a live album, using as few tracks as possible. This meant giving precedence to the ambient mics, rather than the ones right on an instrument. The producer had called those safety mics, and they were indeed too safe. We invited the rooms into the mix. Sometimes the four of us would have our hands on the big console, pushing up faders or muting tracks. Now, automation takes care of all that. Then, though, mixing was a performance in itself and we got good at it.

We used analog technology to our benefit, slamming the two-track mixes into a half-inch tape machine to get that good distortion. The record was done, and it sounded good.

The fact that we did that album in a week is a bragging point. Of course, that was a world of time for those that came before us. All through the jazz age, and for the first two decades of rock and roll, bands would come off the road, set up in a studio and cut a record in a day. Before albums, bands could plow through half-dozen or more songs in a three-hour session. There's a great story about Fats Waller getting a request from a woman to play "I'm

Gonna Sit Right Down and Write Myself a Letter."

"Lady, we don't know that song," Fats said.

The woman insisted they did, and finally settled the argument by playing Fats his own version on a jukebox. The man recorded over 500 songs in his career and drank heroic amounts of alcohol, so his temporary lapse of memory is understandable.

After we got big, I met George Avakian. He produced records for Armstrong, Miles Davis, and Billie Holiday. I wanted to pick his brain about how they got those great string bass sounds in the 50s, but his response was "Oh, Tom. I never touched the mics. I was the producer." *Huh*, I thought. *Sweet gig.*

"Well, tell me this," I asked. "How long would it take to set up a band to record on those records? A small band, like Armstrong's All Stars?" Remember, we had blown two days in Kingsway trying to do this with little to show for it.

"Oh, half an hour," George said. After that, we all went out to dinner and he shamelessly hit on Mel.

As we loaded the van to go home, I turned to Chris P and Ken. "Fellas," I said, "this is a great record. I bet we'll sell seventy thousand copies." This number, of course, was pulled completely out of my ass. There was little hope of achieving sales like that. We were an odd little band out of North Carolina with a solid touring base and good press,

but reviews don't sell albums. There was no way to know what was going to happen. I might have told the guys that *Hot* would sell a million, but it would have been simultaneously preposterous and, ultimately, a low-ball prediction.

When I first moved to Pittsboro I befriended a local shop owner. Andy was a big grizzly of a man, bearded and always wearing suspenders. He owned a curious antique store downtown. He was a lousy businessman. We'd get stoned and he'd play strange Oriental 78s on a gramophone. One was called "Japanese Rumba." Andy played old-time fiddle and got me turned on to Chinese firecracker labels.

He had a collection of them from the 1920s through the 1950s, and they blew my mind. It was clearly mass-produced stuff, but was so gorgeous and exotic. Also, the English was bad: "Lay on ground. Light fuse. Retire quickly." Mel bought quite a few of them for me as a birthday gift, and I'd show everyone who visited my Golden Bat and Atomic Brand labels.

My old restaurant colleague and Mammoth art director, Lane Wurster, asked to see them when he was designing the cover for *Hot*. He came up with something spectacular: our CD as a pack of firecrackers. A great record had a great cover.

Hot was released in June 1996. Without anybody knowing, Jim and Katharine invited our booking agent,

Erik Selz, to Chapel Hill for the record release. During the sessions for Joe's album, Selz had bulldogged me like he did club owners. He called me to the phone in Kingsway because I said I had another engagement for a certain date he wanted to book.

"What are you doing that's so important?" he demanded.

"My brother Dan is getting married," I said.

"Is that something you feel like you need to go to?" he asked.

I paused for a few seconds before answering and spoke slowly, so he'd understand. "My fucking brother is *getting married*," I explained. He was still put out.

A few weeks later, Erik told Jim and Katharine that, in a business sense, no one was minding the Squirrel Nut Zippers' store. There were some minor "housekeeping issues," he said, that he'd be glad to handle—for free! Jim and Katharine invited him down and put him up. It all seemed harmless enough, I guess, until I got a call from Lane.

"Erik Selz is at the label party telling everyone he's managing the band," he said. "Is that true?" I told him it was news to me, and then simmered. There was a screaming match in the dressing room before the show when I confronted Jim and Katharine.

Jim and Katharine maintained that it was their decision to make. The fight was broken up by a photo session.

I remember standing on the sidewalk outside the club, red-faced. In true Zippers fashion, we got onstage that night and played one of our best shows to date. No matter how dire and frigid things would become, we always left emotional baggage on the side of the stage.

After the show, Chris P came up to me, speaking in low tones. "Hey man," he muttered, "I know I didn't say anything in there, but I agree with your position."

"Next time, get my back," I said. I should have wised up. Chris P was careful to separate himself from us contractually, demanding a "sideman clause" in our recording contract for him alone. I was happily signing away rights to songs I was writing and the freedom to even record with other people. Chris P was cannier. He was in the Navy, while I still played pirate.

I won that argument with Jim and Katharine, I suppose, if such a situation can have a winner. Selz backed off, and we carried on representing ourselves. *Hot* was released, and starting having a good little life. We picked up some glowing press. *Pitchfork*, renowned for hating everybody, gave it an almost perfect score. The writer opened with review with talk about scraping his pot pipe and ended with letting us know that both he and his mom loved the album. It was a fantastic, and touching, street cred review—one that would no longer be available once *Hot* broke and we

became responsible for the latest fad.

A couple months later we played the Summer Olympic Games in Atlanta. The city had spruced itself up. The Zippers were installed in a hastily rehabilitated hotel on the sketchy side of town. It was an absolute desert, but there was a well-worn path to the liquor store next door, so that worked out. Someone had the wisdom to put most of the musicians in this place, and the variety was astonishing: a Native American female vocal group, a Texas country band, Cajun Zydeco players, African American gospel singers, and a traditional Irish outfit called Four Men and a Dog. Ken, Chris P, and I hung with them because we figured they'd share our love of refreshments. We were not disappointed.

Every afternoon we'd be bussed downtown to Centennial Park to perform. This was a lovely place and the gigs went well. My dad's sister, Betty, and her family came out to see us. But the real action was happening back at the hotel. Every night there were performances and jam sessions that went almost until dawn. This was unique in our lives. It's hard to get musicians to sit down, let alone stay put for a couple weeks. When they play for each other it goes beyond performance. Musically, there was so much to listen to, so much to say, so many possible combinations and permutations. We cross-pollinated, playing until dawn almost every night.

It ended, as all good things do, and our next show was in Asheville. As we loaded in, someone told us about the bomb going off in Centennial Park. It broke my heart, the thought of that kind of hate in such a lovely place—a place built to bring people together. It also underscored the feeling I usually had when I was out on the road and away from Mel: that I was a balloon without a string, buffeted by the wind and close to being blown away.

Still, for me at least, a dream was about to come true.

Since the early 90s, RCA had been steadily reissuing all of their recorded Fats Waller material from the 30s and 40s, and I was gobbling it up. Fats and His Rhythm were big sellers for the label, and these remastered CDs were a playground. In the liner notes of one three-CD set, I learned that Fats' guitarist Al Casey was still alive.

I loved Al's playing, and emulated him. He used an acoustic guitar, which even in a small band like The Rhythm was hard to hear. Instead of playing mostly single-note solos, like the great Django Reinhardt, Al employed these dense, confectionary chords. His solos sound like he's handing you a bunch of flowers.

Albert Aloysius Casey joined up with Fats when he was a teenager. He told me that Fats made him finish high school, though he was keen to tour. "Show me the diploma," Fats said, and when Al did they went out on the

road. Later, Al took a little time off from Fats' band to play with Teddy Wilson and Billie Holiday. In 1944 he played with Louis Armstrong and many other greats in New York ("I don't know why *I* was there," he told me), and also sat in with Art Tatum and Coleman Hawkins.

My musical heroes were in short supply, most of them being dead and all. Even John Lennon was gone. I had seen Cab Calloway perform once, in the late 80s. Most of his material was schlocky stuff about getting older and the North Carolina Symphony, who couldn't play hot to save their lives, backed him. But when they cranked up "St. James Infirmary" and Cab started that strange, slow motion backwards slink, all time disappeared. He was that man I saw on the film, now in front of my eyes: a friendly, grinning devil.

I was lucky to see Cab at all. The South wasn't friendly to black musicians back in the day. The southern run was called the TOBA circuit, which stood for Theater Owners Bookers Association, but became known by black players more accurately as being an acronym for Tough On Black Asses. "I last played here in the 1930s," Cab told the audience in Raleigh. Apparently at one of his shows in North Carolina, the powers-that-be painted a line down the middle of the hall to enforce segregation. "And they liked it," Cab continued, "and asked me to come back. So here I am!"

And there he was, in North Carolina again, fifty years later. We all laughed, but it was sad as hell.

In the summer of 1996, I looked up every Al Casey in the New York directory.

"I'm calling for Al Casey," I said each time someone answered, and when there was a positive response I asked, "Excuse me, are you the Al Casey that played with Fats Waller?"

One of them said, "Yes. Yes, I am."

I don't really remember the conversation. I gushed and babbled. Al was gracious. I must have mentioned something about performing in New York soon. We agreed to meet. "Stay in touch," Al said before we hung up. He always said that.

We arranged a meeting, and I told everybody. Ken and Jimbo were keen to go too. Keith Hagan, the label's publicist, found out once we got to the city, and before we knew it he'd hired a photographer. We all piled into one of the label cars and headed up the West Side Highway. I was so nervous I lost feeling in my left arm.

Al answered the door of his little apartment, a slender black man with a salt-and-pepper moustache, still handsome at eighty. The first thing I noticed was how long his fingers were. When he saw the hall filled with people, his face flashed in anger. "What is this, an interview?" he

demanded. We apologized and assured him we came as friends. We didn't have to take pictures. He let us in and we met his wife, who stayed in the background. He was polite, but the meeting had gotten off to a bad start.

After some awkward conversation we decided to break the ice. Keith volunteered to go out for some beer. "What do you like, Al?" we asked. He didn't understand. "What brand is your favorite?" Keith asked a little loudly.

"*Beer* is my brand," he said, and that was it. We were off to the races. After a couple tall boys, Al broke out his scrapbook. We were in heaven.

There was a three-quarter publicity shot of young singer and actress Dorothy Dandridge. God, she was hot. On another page was a photo of Fats' big band, posing in front of their tour bus. Above his wide frame, in spidery cursive, Fats had signed "Boss Man."

We began to speak like old friends and killed off the tall boys. The photographer clicked away, sometimes annoying Al.

We discussed life on the road and what gauge strings we used on our guitars. Al mentioned that he still had his old Gibson L-5 in the closet. In the late 30s, Fats and His Rhythm made a few Soundies (the first music videos). Al plays a beautiful solo on "Honeysuckle Rose," and for a moment you see him, a young man, cradling that Gibson

like Madonna and child.

In 1996, though, Al couldn't get much attention. He had a steady gig in New York with other pre-war jazz veterans, The Harlem Jazz and Blues All-Stars. Few people came to their shows. The All-Stars made money by touring Scandinavia, where they were treated as heroes.

Back in Al's apartment, the beer was gone and the pictures taken. It was late afternoon, and time to go. We thanked Al, and promised to meet again. There was an idea, briefly discussed, of performing together. We filed out, and before he closed the door, Al said, "Stay in touch."

Ken and I played a duet on guitars for "The Interlocutor." If you listen to my chorded solo, you can hear me trying to sound like Al Casey. You ought to buy some Fats Waller music and hear the real thing.

CHAPTER THREE

SATURATION RESEARCH

THE SQUIRREL NUT ZIPPERS WERE STILL BUILDING
up a solid touring base. We had started with the South-
east, naturally, and found a large and enthusiastic follow-
ing there. The label despaired when we told them that we
wouldn't go to any new market without making money,
but even that didn't take long. Something was in the air.

People were ready for our strange take on pre-war era jazz. Our trip to the West Coast made that clear.

We continued in this pattern, releasing an album a year and methodically breaking new markets. We were able to record *Hot* in five days in a studio we could scarcely afford because we had been touring most of that material for months. Released in June of 1996, *Hot* sold more than *The Inevitable*, if only just.

The next record had to be done differently. Many of the new songs hadn't been arranged, much less road tested. We needed more than six days to make the new album. Friends of mine in Pittsboro had bought Hilda Bell's place and told me it was for rent. It was right for recording: wood floors, plaster walls and nine-foot ceilings, but it needed some work. There were no right angles in the house. A former owner had installed a picture window in the living room and poured a concrete porch out front. Over the years the porch leaned in such a way as to funnel rainwater straight down into the foundation. The front wall sagged. In the room we called "Club Inferno," the oak floors tilted and squeaked, its walls lined with peeling, repetitive wallpaper illustrating a bland Antebellum scene. Surrounding the place, a tangle of overgrown forsythia, Rose of Sharon and camellia, burying stone flowerbeds and retaining walls.

Hilda Bell had been a music teacher, from her home on

East Salisbury Street in Pittsboro, North Carolina. An old neighbor told us stories of hearing her pump organ through an open window on summer nights. Someone gave us an early-century picture of her expressionless mother holding a baby in the front yard. It was the autumn of 1996, and the Squirrel Nut Zippers were looking for a place to record our third album. The Bell House was for rent and my girlfriend Mel and I had crawled in through an unlocked window to check it out. The rent was $250 a month.

Ken moved from Saxapahaw to live there. Saxapahaw was a languishing mill town near the Haw River, a twenty-minute drive through rolling farmland from Pittsboro. This was a step up for Ken. The year before, documentarian Clay Walker had filmed him in his house at Saxapahaw. We see Ken, caged inside a thicket of copper pipes, claiming to fix the plumbing.

In honor of its new tenant, Hilda Bell's place was rechristened Kensway. Like Kingsway in New Orleans, it was a house repurposed for recording, but the similarities ended there. Once we had scrubbed it down and fixed up the plumbing and electricity, Mike Napolitano brought recording gear from New Orleans. He was our producer now, which meant helping us install an eight-foot mixing console and refrigerator-sized tape machine into a tiny back room.

• • •

The album's beginning wasn't auspicious. I felt great about finding a big old house in Pittsboro, right up the street. I loved that Ken had moved in. It was a smart investment and a place of our own. Kingsway was a palace, but even their sweetheart deal was something like $1,200 a day. Two hundred fifty bucks a month gave us a lot more latitude. Further, it seemed an extension of our DIY attitude, because we always did things on our terms, and now owned quite a bit of good recording equipment that could be used on subsequent projects. Still, the band's married couple, Jim and Katharine, balked as the session approached. They suggested we use a local studio and then went on vacation. We created Kensway without them.

Andrew Bird came down for the Kensway sessions. Ken and I picked him up from the airport in my '69 Plymouth Fury. We decided to play a joke on him. A simple, dumb gag that Kenny told me with a straight-ahead set-up and punch line:

Ken: Did you like to blow Bubbles when you were a kid? Just say yes.

Tom: Yes. Yes I did.

Ken: Well, he's back in town and wants you to give him a call. (Cue Ken's phlegmy, vaguely despairing laugh.)

We greeted Bird, tossed his luggage in the enormous

trunk, and got him situated in the back on the big green bench seat. We passed a few miles engaging in small talk as the countryside turned to fields and farms.

"Hey Bird," I said. "Did you like to blow bubbles as a kid?" Ken and I exchanged adolescent smirks. A few seconds went by.

"You know, it's extraordinary that you bring that up," said Bird, his voice soft and intense. "I've never really talked about it, but my fondest memory is of blowing bubbles." Oh, god. He was so earnest. Worse, he thought this was an opportunity for meaningful connection. He went on for quite a while.

"Why do you ask?" Bird said at last.

"No reason."

I have two main memories of Bird during these Kensway sessions, besides his marvelous playing. I see him now, in his mid-twenties, at the kitchen sink, thrusting his arm into ice water for twenty minutes. "It helps the pain from the nerve damage," he told me. Another time he was recording an overdub in one of the rooms. To limit the ambience, we had propped up a door to block the living room. Ken, Mike, and I were back in the control room. Bird was really playing well, and it seemed like the "keeper" take, when there was a terrible crash. It honestly sounded as if the roof had fallen in. Andrew kept playing.

We rushed in to see if he was hurt. Turns out the door, which wasn't secured with hinges, had fallen back into the living room. "Didn't you hear that?" we asked incredulously. "Yeah," said Bird, "but I kept playing because it was such a good take."

Kensway was a strange approximation of Kingsway, without the baubles and gaudery. Ken, Mike, and Bird stayed upstairs, like we did in New Orleans. Ken would cook, wearing a 1930s "Wot'll It Be?" apron with a cartoony drawing of a striding man holding a tray of booze. There was a freestanding, ugly 70s bar in Club Inferno, next to the saggy red pleather couch we bought for a dollar. This is where we served white lightning acquired from the western part of the state, euphemistically called peach brandy. It was tasty and hit you like a baseball bat. The cops came by at least once, when Chris P was recording percussion overdubs at two in the morning. They suggested politely that maybe it was time to stop for the night.

The summer before the *Perennial* sessions, Chris P made one of those musician-makes-a-little-bit-of-money purchases, filling his living room with a giant, pitifully out-of-tune nickelodeon. It was an upright piano with a self-playing drum and percussion. One of its tuneless, unidentifiable songs has place of pride on the record. It sounds like Harry Parch porn music.

• • •

The Zippers lost a member before every new album. Before *The Inevitable*, Jim and Katharine tossed a sax player out. Stacy was asked to go clean up a few weeks before the *Hot* sessions.

One of Stacy's former band mates, Jé Widenhouse, was brought on board. Jé had a good tone and an easygoing personality. We called him Freep. He was short, with messy hair and a moustache, and lived several hours away in Asheville, the big city near Burnsville, where I grew up. He was already married and had a kid. By the time of the *Perennial Favorites* sessions, he had been in the band for almost a year. But the lineup was becoming unstable again. Bassist Don Raleigh was unhappy. His songs weren't getting worked up.

Don's a good writer. His song "Anything but Love" led to our first big break. It appeared in the movie *Flirting with Disaster* and was covered by Dr. John. Don couldn't carry a tune in a paper bag, so it was hard to figure out the melody of whatever song we were learning. He also used a strange vocabulary during rehearsals, saying things like, "It should sound more like a cloud." Before the *Perennial* sessions, Ken and I worked pretty intensively with Don to work his new material into shape. Katharine didn't really want to do any of that. When Don talked to me about his

frustration, I realized my supportiveness had a limit. By this time there was pretty fierce competition to get songs on the record and I had my own stuff to worry about. Ken essentially stopped contributing songs altogether, becoming Kensway's studio manager and housekeeper since no one else could really be bothered. He told me that Don went to Jimbo and demanded two songs on the new album. We completed one, "Dancing on the Moon," a high-energy number performed during that year's Summer Olympics, and started tracking another, "Cat Town." Katharine was so resistant to sing the latter that she got drunk on gin. I liked the song, but it was never finished, and "Dancing" didn't make the record either. Don walked out of the session and disappeared. We later found out he'd gone to Costa Rica.

It was a hard blow, but one we didn't have time to absorb.

Don made the decision to leave. I wasn't about to, but I had my own unmet expectations. Once, I returned to Kensway from eating dinner with Mel to find "Fat Cat Keeps Getting Fatter" completely tracked. I felt excluded. Jim and Katharine later expressed a similar disappointment when I asked classical musician Emily Laurence to play concert harp on "The Kraken." "None of us can *play* harp," I said. Jimbo brought a one-eyed, dangerous-looking

Vietnam vet named Hawkeye to the sessions. He was a nice guy and played a good mandolin, but things were strange. They recorded "St. Louis Cemetery Blues" in the kitchen, on Ken's primitive digital recorder. It was, in my opinion, better than some of Jimbo's other songs that made it on the record and I lobbied for (and got to play) bass clarinet on the track. I originally offered my song "Pallin' with Al" to Katharine for lead vocals, but decided it was so personal I wanted to do it myself. Once we got to *Perennial Favorites* I wasn't really writing for the band anymore. In other words, we were breaking up.

We finished the session with a revolving door of string bass players. Some of them were technically very good, but none had Don's feel. I masked the pain of Don's departure by thinking, *He shouldn't have made an ultimatum.*

Our label, Mammoth Records, usually left us alone when we recorded. Their request for demos or occasional visits to the studio were benign affairs, so it was unusual when a week or so into the session they demanded to meet with us right away. The band met preemptively to figure out the label's motivation. *Hot* had done tolerably well, and our tours were successful, but maybe the combined recording and publishing advances were too much. Perhaps the unserious demos we submitted were too provocative. It was decided we were getting dropped. We ushered the label

guys into Club Inferno. Though amused at the improbable recording space, they acted strange.

"You have a hit song," said Steve Balcom. He was the vice president of the label, and our main contact. Silence, as we traded glances.

"Whose is it?" I asked.

"It's your song, Tom. 'Hell.'"

The second thing that went through my mind was: *How long will this last?*

The energy in the room was heavy. On one side there were label guys, looking around with barely contained enthusiasm. On the other, the Zippers, reacting quite differently. We exchanged furtive glances and asked questions like, "What does this mean?" I had the distinct feeling that, because "Hell" was my song, it was going to cause trouble.

"Hell" was never worked as a single. "Put a Lid on It" was. The video I directed for that song hadn't even gotten airplay. In it, we break into a house, perform the song, and take things that have personal meaning but don't belong to us. At the end, Katharine, wearing someone else's dress and makeup, pours gasoline down the stairs and out to the waiting car. She lights a match but blows it out. MTV thought this was too dangerous and cited some recent case of *Beavis and Butthead*-inspired arson. I figured they wouldn't air it because I wasn't on their list of approved directors.

The video was based on something that had happened to Mel. People broke into her apartment, ate her food and tried on her makeup. It was too creepy to pass up. In my mind, the house in the video has always been the American Museum of Jazz, where you could look but not touch.

"Hell" was initially played as a joke on LA's biggest rock station, KROQ. It wouldn't have been played at all if Tom Osborn, the West Coast label rep, hadn't bugged them endlessly. But when the phones lit up the station knew they had a hit.

"Let me tell you what's going to happen," said Keith, the publicity guy, in a company car as we drove through Manhattan a few weeks later. "*Hot* is going to go Gold in the spring, and Platinum by the fall."

"Keith, Gold means selling a half-million records, and Platinum is a million," I said. "You're just making that up."

"No," he said, "trust me."

"How do you know this?" He seemed so certain.

"Just trust me."

Radio had the same certainty. Predictive models showed "Hell" could possibly go to number one. Then there was something called Saturation Research. Using marketing groups, the radio people discovered just how many times "Hell" could be played in a day, every day, before people began to hate it. The object, I suppose, was to

wring as much airplay (and profit) from the song by burning it out, making way for the next big thing. We were told they couldn't find the saturation point for the song. People didn't want to stop hearing it.

The Zippers knew none of this, of course. Our world wasn't quantifiable like that. We played parts that felt good, and were not written them down. Our ambition was to put on good shows and make good records, not to take over the world. We never really conformed to expectation, which is what made us so interesting. Even as we met with the label in Club Inferno, the Squirrel Nut Zippers' future in the industry was being laid out on charts and graphs, but the band's future was increasingly uncertain.

I had written "Hell" almost three years previously. The riff came to me in the car as I approached a stoplight. I didn't have to worry about rushing home and getting it down. I can't really write music anyway, and didn't have any kind of recording equipment. Besides, it wasn't going to get out of my head until I heard it played. I liked the way it repeated itself, as if trying to emphasize a point that might not be understood.

I had unconsciously been working on "Hell" most of my life. It was the decades-delayed response to listening to frantic evangelical preachers on the AM radio. When I

was six, we had moved from Fort Lauderdale, where I was born, to the tiny Appalachian town of Burnsville, North Carolina.

My dad, Joe, is the eternal Boy Scout. He was born in Birmingham, Alabama and became an industrial designer. He was on the team that designed Whirlpool's Miracle Kitchen, the site of Nixon and Khrushchev's famous debate. It had a microwave and a self-propelled vacuum cleaner. Dad told me that much of that stuff was faked because the technology was unreliable. By the early 70s, Dad decided that Fort Lauderdale was no place to raise kids and packed us off to live in our summer cabin high on a mountain in Burnsville. We moved the Korean War-era Jeep out of the living room and made a home. Our nearest neighbors were a mile away.

My mom, Nancy, was a city girl from Toledo who became an English teacher. She used to sneak into Detroit clubs to see the big bands play in the 50s. Once, when seeing Louis Armstrong emerge from an elevator in south Florida, she had to restrain herself from hugging him.

We appeared to be of means because we were outsiders and owned a new Chevy Blazer. Some locals asked us if we owned Maxwell House coffee. Floridian tourists would appear in the summer months, as we used to, on vacation. As I walked along the steep dirt road, they would stop their

cars and speak to me loudly and slowly:

"Excuse me! Do you have television? Is this plant edible?" They over-enunciated.

The mountains did allow some weak radio and TV signals. I sat closely to my dad's shortwave in the log room where I slept with my two older brothers. The local station, WKYK, holds little memory besides the hellfire preaching and the maudlin song played at the end of each broadcast day, "Climb Every Mountain."

The religious broadcasters described, breathlessly, how one could be damned. Attending the wrong church would do it. Their programs were a half-hour run-on sentence. It scared the shit out of me. I heard nothing but rage and retribution. Even after I had gone off to college in Chapel Hill in the mid-80s, a group of Holy Rollers pulled their bus up to the auditorium during a middle school dance and began hauling kids out, putting them on their bus to save them. This kind of stuff only solidified my growing identity as an outsider.

My family was not Baptist. We were vaguely Presbyterian. We attended church so seldom that the minister once asked us to stand up with the rest of the visitors. It was an unsubtle, passive admonishment: we had been there before. Nevertheless, I began to have religious feelings around puberty. I lay in bed, extending my arm in

the air, imagining—feeling, really—a hand reaching down to grasp mine. The connection was never quite made. At other times I couldn't shake the image of a disgusted God, wadding up my paper prayers and throwing them away. I can't remember what I prayed for. Probably help to make me stop masturbating.

In the meantime, I was introduced to rock and roll by my oldest brother, Dan, who brought home those records by Led Zeppelin, The Rolling Stones and most important, the Beatles. We would "jam" in the walk-in closet, Dan playing air guitar and me on air drums, using pencils for sticks.

Middle brother Steve's musical taste was more recent. He listened to The Clash, Bow Wow Wow, and Soft Cell.

At UNC I read James Joyce's *A Portrait of the Artist as a Young Man*, recognizing the preacher's intricate description of hell. On and on it went—putrification without decay, heat without light, regret without reconciliation. The tedious and lengthy passage about eternity stuck with me. It involved birds and grains of sand. By this point— seventeen, recently deflowered and with a self-confidence only ignorance can provide—I smiled at the quaint over-statement. That year I gave away the copper cross I first wore to college. The last remnants of those beliefs were dusted away in the coming years by Joseph Campbell's

books on comparative religion, or Stephen Jay Gould's marvelous essays on evolution, all of which I read after college. Well, almost: the message of hell, and how it was delivered, stayed with me. I was drumming in rock bands even before I graduated. It was, I suppose, an indirect way of using my communications degree. I had no thought of a proper job, never felt cut out for one. Still, I couldn't fully accept who I was. Music was fine, my parents counseled, but only as a hobby. I needed something to fall back on, like being a doctor or a lawyer. I came to terms with my identity in 1988, high on trucker's speed, in a parking lot in Wilmington, NC. *You're a musician*, I thought with relief, looking up into the empty sky. *It's who you are, and it's okay.*

A few years later, John Ensslin and I were driving home from band practice. A 1930s calypso came on the Chapel Hill college radio station. The minor-key riff, played by trumpet and saxophone, rose like a shroud from the flagstones.

"Turn it up," I said.

By this time I was familiar with Cab Calloway's white tails and wide smile. I was buying Fats Waller records and listening to his unsettling pipe organ blues. I knew and loved Django Reinhardt and Stephane Grappelli's *Quintette du Hot Club de France*, so sweet and a little sad. I was

digging deep into the heat of Duke Ellington's music from the 1920s. I had even heard calypso: the Andrews Sisters' sunny, mutated version of "Rum and Coca-Cola," so far removed lyrically from Lord Invader's original song about mothers and daughters whoring themselves to American GIs during World War II. My parents' non-threateningly exotic Harry Belafonte record was called calypso. But it sounded nothing like what I heard that day: "Seven Skeletons Found in the Yard," by Lord Executor.

The horns clash and bounce. The riff, with its curious stops, burbles with urgency and menace. Executor's delivery is more recitation than performance, with a newsman's detachment. Clearly, he has an important message, but the lyrics are so dense and his patois accent so thick as to make it nearly indecipherable. How could a band with no drums be so rhythmically tight? How could any music be equal parts Cuban and klezmer? A call to WXYC identified the song, as well as the CD on which it had been reissued: Rounder Record's *Calypso Breakaway*. I bought it. Rounder and other labels had issued several such calypso compilations. I collected all I could find. Listening to calypso was like discovering a hidden room in your childhood home.

Structurally, old school calypso is much like blues. Calypso chord changes are almost always of two variants:

single-tone, using only two chords, and double-tone—similar, but with an extended middle. Blues also has a (usually) standard set of changes. Many, if not most, of the 30s calypsos are in a dark, minor key. Their instrumentation, even the backing band on the recordings, is similar if not identical. Like blues, the riff, the melody, and the singer's personality distinguish the song.

In the months after our first record, *The Inevitable*, was released in 1995, I wrote a new batch of songs. Jimbo cranked them out consistently while I puttered and fussed. I had a few good ballads, but we needed a set closer. As I read *The History of Hell* by Alice K. Turner, it dawned on me that this was perfect calypso material.

I was ready to take another crack at the form once I had found my theme. Heaven, all harps and clouds, holds no interest. Hell is an artist's playground. If I sang about hell, I would labor in an ancient vineyard. I would create an antidote for the AM preachers' fearful certainty. I would console myself by taking a hardline against jerks rewarded for bad behavior.

Initially, the lyric was just going to be a lengthy list of torments, but that got old pretty quick. One verse survived:

The is a place where eternally
Fire is applied to the body

Teeth are extruded and bones are ground
Then baked into cakes which are passed around

I changed the last line from "rolled into joints which are passed around" so as not to disturb the 'rents. Besides, it reminded me of an old Bugs Bunny cartoon where Elmer Fudd, playing the giant to Bugs' Jack, threatens to "grind your bones to make my bread!" Then he produces a peppermill and says cheerfully, "This should grind his bones very nicely."

It felt, as the best songs do, like it always existed. In some ways it had. I've never thought I created "Hell" out of whole cloth. The theme was planted, eons ago, in the Tigris-Euphrates Valley. The music is standard single-tone calypso. I had written something, I believed, that could have been performed in a Carnival tent in Port of Spain, but only by the Squirrel Nut Zippers.

I brought the lyric sheet to the next Zippers' practice at Ken's house. Chris P was setting up the drums. I told them excitedly about the new song and read the words. When I finished, Chris P looked up from adjusting his bass drum legs.

"Jesus, man," he said, shaking his head. "Goddamn." Ken just laughed.

• • •

The lead vocals for "Hell" were recorded during the *Hot* sessions on Halloween night, 1995, in the mansion that was Kingsway Studios. I wore the blue silk Chinese gown I'd bought in San Francisco's Chinatown earlier that year.

During the vocal take, Ken sang backup and played alto sax off the mic behind me. Because I needed quite a bit of air to sing, I did what Katharine taught me to do and raised my hands over my head before the take, bumping the crystal chandelier. It emitted quiet, ghostly tinkles. "Do that again," Ken said. "That's a cool sound." During the next take I shook the chandelier, gently. "That's not getting picked up on the mic," said Ken. "Shake it harder." And so I did, with each successive take, until one of the glass arms came off in my hand. "Shit!" I hissed. I spent the following solo breaks trying desperately to fit it back in, until the end of the song. Flat on my back, I bellowed the loudest, longest scream I could manage. The goal was to channel all the great screams I had heard over the years: Wilson Pickett's blow-out howl at the end of the Falcon's "I've Found a Love," Little Richard's shrieks on "Keep a Knockin'," the pain and fear in Lennon's voice on "I Want You (She's So Heavy)" and "Mother." At the end of the take, I stood up, still holding the glass arm. "I broke the chandelier," I said dejectedly. We left that in.

The next morning I sat on the grand staircase, hung

over, and bummed out. Katharine came beetling up from the kitchen. "Do you *know* what you did to the chandelier?" she snapped, as if I was a common vandal or a blackout drunk.

A note about Ken: at one time, we gave each other calypso-style power names. Ken's was Lord Escalator because of his ability to escalate any situation. During the recording of "Hell," he somehow convinced me to break an expensive antique light fixture, but it was nothing like when he talked a New York cabbie into a drag race with another cab down the avenue one night. I will never forget the rapid acceleration as the challenge was met, and the expression of the passenger in the cab opposite me as her car suddenly took off. Her face, pressed against the window like mine, was one of terror. I was her mirror.

Back in Kensway, as 1996 dragged to a close, what was to become *Perennial Favorites* was completed. The sessions were four times longer than *Hot*—meaning it took two and a half weeks this time—and what sticks with me is how strange and difficult it was.

The label was now in constant communication. Ken bought a nice new speakerphone, so we could conference with the label in Club Inferno. He never took it out of the box. Instead, he made some Frankenstein's Monster out an ugly green rotary phone and a crappy mic, all duct-taped

together. It emitted a loud, headachy buzz. We used it exclusively. I was reminded of a story about Brian Wilson from the Beach Boys, who attended one late 60s meeting at Capitol Records without uttering a word. He brought instead a portable reel-to-reel machine, on which he had pre-recorded his responses. When I think about it now, I don't really understand why we sat there for hours on end, listening to that awful noise through that shitty, home-made monstrosity. ("Of course you do!" Ken just said on the phone. "It was a poke in Mammoth's eye. We knew they were going to poke us anyway." We did, that's true. But that distracting, insistent humming sound was just as loud on our end.)

The sessions ended because they had to. We needed to go on the road. In January we played President Clinton's second Inaugural Ball in Washington, D.C., and turned right around to make the video for "Hell" back home at the Cat's Cradle. I co-directed it with Norwood Cheek, an old friend. The concept was simple: an episode of *The Lawrence Welk Show*, directed by David Lynch.

We shot most of the "Hell" video in a day, on 16mm film. Somebody got a hold of a red velvet curtain, campy tuxedos and a wonderful *Price Is Right*-style microphone for me to hold. Almost everyone in the band has a vignette: I am a demented dentist pulling a giant tooth from Mel's

head with pliers. Chris P, his mouth taped over, does an awkward tap-dance routine wearing a ball and chain. Ken and his date break their wine glasses during a toast and spend the rest of the video picking up shards of glass. Jim and Katharine watch themselves on TV and laugh until their spirits leave their body and dance, and trumpeter Jé Widenhouse looks on with bug-eyed enthusiasm as a horn held up with fishing line jumps to Duke Heitger's solo.

"I'm not going to pretend to play something I didn't do," he said.

By the end of the video for "Hell," my face is caked with red makeup and a black circle is painted around one of my eyes. It's a strange signifier. Pete the Dog has one in the *Our Gang* shorts from the 30s. There is also a Disney movie from the 60s in which an intelligent goose with a circle around its eye helps a man escape from a basement. The circle is significant—maybe of some extra-animal intelligence—but nobody knows why. So I had one too, screaming my balls off, enveloped in bubbles. (I wanted to be engulfed in flames, but was reminded in the editing suite about MTV's aversion to fire. I also wanted to insert subliminal messages into the video—quick flashes of innocuous text saying things like "There is no hell" or "Love each other" or "Do good work." The idea was roundly rejected.)

The best video for "Hell" will likely never be seen by a

wide audience. A fan, whose job was transferring old home movies to video, made it. The video was a collection of oddly related clips from the 60s and 70s: a young woman waving a pistol in front of an outdoor grill, a mother pushing her baby carriage up a steep sidewalk and doing it again when it rolled back to her, and then—right in the middle—a shot of a waving clown on water skis. It was an absolutely unnerving masterpiece. I haven't seen the tape in years.

In 1997, "Hell" peaked at number 13 on the Billboard Hot 100. The next tour we did was on a bus, instead of the cramped, moldy fifteen-passenger van.

CHAPTER FOUR

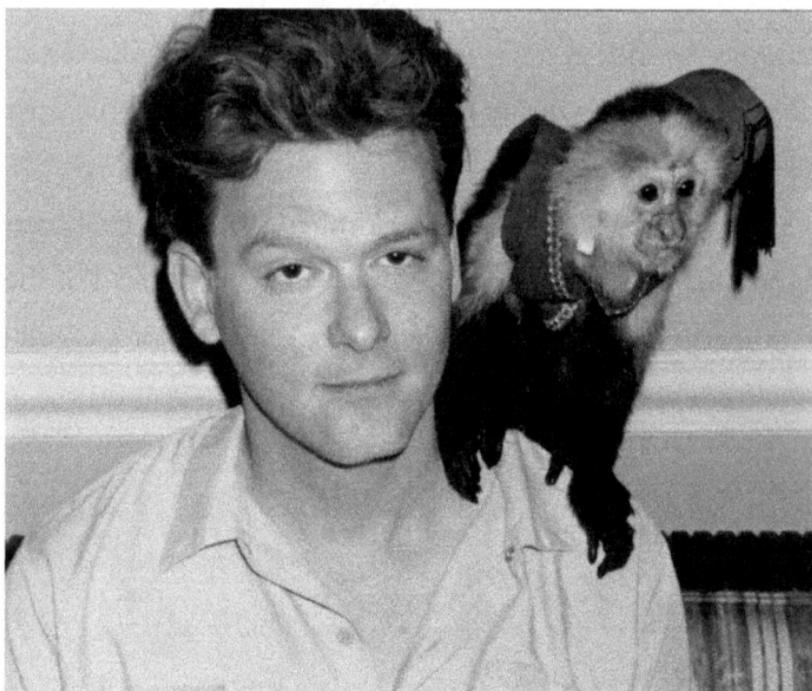

NINETEEN NINETY-SEVEN WAS THE YEAR THE Squirrel Nut Zippers were shot out of a rocket. We took off. Most of the other descriptive terms people used were ultimately more accurate: we exploded. We blew up. I guess we did. Ken says it was like being trapped in an elevator with no buttons. It was a hell of a ride.

Whatever we were doing must have been right, because nobody in the media could agree on what the fuck was happening. We were described as innovators and rip-off artists. We paid homage to the music we loved, but were also ironic hipsters poking fun. We pissed off jazz purists, who hated talking about us, as well as corporate radio program directors, even as they put us into heavy rotation. "Hell" wouldn't have been a hit without the Swing Revival, and there would have been no Swing Revival without "Hell" becoming a hit.

Whatever the real story is, you won't get it from me. I was so freaked out by what was happening that I grew a moustache that couldn't be seen until it was darkened with eyeliner.

Stu Cole was hired to replace Don. Stu had been around the Chapel Hill scene like us, playing in The Chicken Wire Gang. He is a better guitarist than me, for sure, and had decent bass chops. He's a go-along, get-along kind of guy. Ken and I wanted to hire Jimbo's old high-school friend, Tray Batson, who appeared during the Joe Tullos session and seemed to fit right in. But Jimbo wanted Stu, because I think Stu understood it was Jimbo's band. "He knows where the keys to the cupboard are," Jimbo said. Stu never signed the partnership agreement.

Ditching the moldy van for a tour bus meant that none

of us should have to continue suffering from what I called Van Dementia.

I first caught the disease when we drove to a college gig in Ames, Iowa. Driving to a distant show without performing along the way is called deadheading. This is only done for big money gigs. About three states in, as endless fields of corn rushed by, I was possessed by the urge to jump out of the van. All I needed to do was reach over and open the side door and I'd be free. It actually took some effort not to do this.

The rest of the band made puns on the word corn until it was no longer funny. Then it was funny because it wasn't funny, like a Jerry Lewis movie. Then it was psychotic. Katharine laughed and cried at the same time: a clear case of Van Dementia.

We were addled when we got to Iowa. There was a contest at the university to see who could kiss a truck the longest. The winner would get the truck. We schlepped our gear past people with their lips against the side of a pickup, shaking in their prolonged effort to stay still.

On stage, Jimbo said, "It's great to be in Idaho." The crowd was dead silent. He looked around at us in a panic. "What the fuck did I say," he stage hissed, "Ohio?" I would have corrected him but couldn't remember myself. Van Dementia.

The tour bus was a big improvement, sort of. If you tour in a van, you need to book hotel rooms, for showers and naps. You can sleep on the bus, which sounds cool, especially if you're a vampire. The bunks were coffin-like affairs, with curtains and low ceilings. I'd often whack my head when springing upright trying to remember where the hell I was. The first time I lay in one, the tour manager gave me some advice.

"Put your head towards the back of the bus," he said. "That way, if we wreck you'll only break your legs and not your neck."

He also told me something to the effect of: "If the bus leaves the road in an accident, we're all pretty much dead." There were, after all, no seatbelts in the lounges or the bunks. Also, you can't take a crap on a tour bus. And most of the windows don't open.

I loved the tour bus. It was a freeway submarine. The drivers were very good and usually nice. I often sat in the jump seat next to them, listening to the intermittent crackle of the CB radio, observing braking distance. Up there, the windshield was a curtain wall. The jump seat had a seatbelt, but I never wore it, just as I never wear one in a New York taxi. None of it feels quite real. We put a coffee maker in the front lounge and installed video games in the back. We smoked back there, like savages. The generator

and transmission made a comfortable rumbly hum. The buses could be as long as forty-five feet—the length of a whale—and the drivers usually kept the tires a lovely, shiny black with some kind of cherry-smelling spray. The first thing everybody did at the start of the tour was race to the few closets in the hallway and back lounge to hang up their outfits. I always thought this was kind of selfish, but I was also too slow. Middle bunks (they were stacked three high) were also a premium. I tried not to sleep on the bottom bunk. Ken got peed on by a sleepwalking tour manager when he did that once.

We were in a bus that crawled through the mountains of Colorado when a blizzard covered the guardrails in snow. We were in a bus that dragged through the Mojave Desert with a broken generator (and thus no air-conditioning) and non-opening windows in August. When we played summer music festivals with a bunch of other acts, the busses would be lined up for a quarter mile in the hot parking lot, their generators burring away, the concentrated heat softening the asphalt.

At one of President Clinton's Inaugural Balls in January 1997, we were billed with LL Cool J and Usher. Before the show, we went around and saw other acts sound check in different venues. Ken, Chris P, and I discussed who would assault Kenny G with his own soprano saxophone. Our

performance was in the Postal Museum, which is no kind of music venue, being a gargantuan marble hall. They had police barricades twenty feet in front of the stage, and people were getting crushed. Mel found a marvelous old dress in the Pittsboro second-hand store, Beggars and Choosers, and wore it for the occasion. The top was a green sequin, with a stained ivory satin bottom. It cleaned up nicely, and only cost six bucks, maybe more with the elbow-length gloves. People stopped her to compliment the outfit. Jim and Katharine got to meet the President and First Lady.

At some point, we found ourselves outside the venue on a red carpet. Uma Thurman was in front of us. She looked like a star, tall and lovely. The flash bulbs were winking like fireflies. When it was our turn, no one took pictures. They didn't know who we were. "It was all very strange until the fourth glass of champagne," I told an interviewer from *The Onion*. "Then it was business as usual." I also told him that my goal in being a professional musician was not to go back to bartending and to keep my 1969 Plymouth Fury in working order. You can take the dishwasher out of the kitchen, I suppose, but don't put him on a red carpet.

That night, back at the hotel, a musician friend came into our room, very excited.

"My boy from the FBI hooked me up!" he said, waving a plastic sandwich bag full of pot.

"You ain't got no fuckin' friend in the FBI," I observed, before pointing out that those government boys probably did have some really good shit. We all smoked a little. Things got. . . strange. My eyes shrunk down to pinpoints. People began to tussle. I looked over and saw Keith white-knuckling it in the chair next to me.

"I think I should go," he said, not looking at all well.

"That's a good idea," I told him in slow motion.

Keith managed to make his way downstairs and saw a familiar woman standing outside the front door of the hotel. She was so familiar—did he know her? Stare as he might, he just couldn't place her. He also couldn't take his eyes off of her while he tried to work all this out. As she got into her taxi glaring at him, Keith finally realized she was Sheryl Crow. He yelled his apologies after the departing car.

The video for "Hell" made it into the MTV Buzz Bin, where it played constantly. I remember doing an interview for their show *120 Minutes*, when I guess we were still considered alternative. Before too many months were out, the song was being used as background music on an MTV program in which Daisy Fuentes helped regular girls try on the right bikinis. I know this because I saw it and felt deeply alienated. At one venue, Indian girls dressed in traditional saris brought us food. They said it was a gift because they had heard "Hell" and it fit right in with their

Hare Krishna religion. Or so they told me.

After *120 Minutes* we did *Regis & Kathie Lee.* For that show, I taped a sign on the back of my guitar that said "Hi Mom!" I knew she'd be watching. This was the thing about the Zippers. Our audience had a broad base. After one outdoor show for a radio station on the West Coast, I made my way through the crowd to get a hot dog. An older woman, maybe in her sixties, stopped me.

"Are you in the Squirrel Nut Zippers?" she asked.

"Yes ma'am."

She told me how much she loved our music and enjoyed the show. "And my mother likes it too!" she said, pointing behind her. I looked and saw a little old dear in her 90s wave to me. *We've tapped a real mainline,* I thought.

By May we had done a half-dozen network TV appearances and numberless club dates. A typical day would involve getting up around eight or nine in the morning to do a radio spot, then maybe an in-store appearance at a record store. Then it was on to the venue for sound check, a quick dinner, a little downtime (unless there was an industry meet-and-greet), and the show. Bus call would be around two in the morning if we were headed to another town. I might have gotten to sleep around four. In a few months my body gave out. I got strep throat and Katharine contracted bronchitis. I remember being in Canada, sick

with a fever. Chris P was furious when he saw me smoking a cigarette. Not, it seemed, because he worried about my health. He didn't want me to cause any cancellations. Things were changing in a fundamental way. We took a little time off, because I had something big to do.

Mel and I got married on May 17, the day after *Hot* was certified Gold. My friends in The Two Dollar Pistols played. Chris P was their drummer. The whole band came out and we had a wonderful time. This was a very bright moment. It was a promise, just come to fruition. I loved Mel dearly. She and I had been together a long time, and knew each other well. By the spring of 1997, with the internal fissures in the Zippers starting to crack, my balloon was in need of a string.

Our life together was good. We cooked Indian food and drank wine. We lived in a little house in Pittsboro. The screen porch overlooked a creek. Clay Walker did an interview with Mel and me there in 1996. We sat together on the couch, holding hands. Mel's hair was long and dark, framing her lovely cheekbones. "I'm one-sixteenth Cherokee," she told me. We were in love.

Mel was smart and funny. Hers was a quick, biting wit that could deflate even the most puffed up personality.

One day before the wedding, Mel's grandmother came to visit. We showed her where we were going to get married,

a little bridge in a field by a big oak tree. "It'll probably rain," she said, and followed quickly with "every drop of rain that falls on your wedding day is a tear you'll shed in your marriage." I think she made that aphorism up on the spot.

It didn't rain that day. It was perfect. I had a gold silk suit made for me that didn't really fit. Mel wore a satin gown based on a dress from the 20s we had seen in a store in Asheville. She was luminous, standing on that bridge. As I walked nearer my knees got wobbly, but I made it nonetheless.

The preacher stood next to Mel. He had advised me in a pre-wedding meeting to "lay her under a hay stack" to keep things interesting. (He also told Mel that "wearing an old t-shirt gets you old t-shirt lovin'.") We had written out our vows, which he forgot completely. Mel and I looked at each other, laughed, and started a new life together.

That night Chris P ended up in Chapel Hill with Nappy. They were pulled over. Chris P was driving. As he was performing the field sobriety test, a slapping sound was heard coming from his car. He looked up to see Nappy mooning the cop from the passenger window. He was spanking his own bare ass.

"Oh, you did it now," said the officer. Both were hauled to jail.

Nappy told me later that he knew Chris P was going

down, and didn't want him to be alone. This is the best story I know about Nappy—not the most ribald or preposterous, but the best. If we die at the same time and I get some bad news at the Pearly Gates, I hope to hear Nappy spanking himself behind me.

Back in the Zippers, the general questions in interviews started to change. Not that they got any more interesting, generally speaking. People still asked about our name. We started hearing from more interviewers about the Nut-Zipper candy pulling out their fillings. Now they wanted to know what kind of music we listened to—new music, like Swing music. I babbled on and on about Fats Waller and Cab Calloway, but that's not what they were driving at. They were also interested in whether we smoked cigars and drank martinis and wore zoot suits. "That's just something the brothers wore up in Harlem back in the day," Jimbo told them. I pointed out that this didn't have anything to do with music, and when they persisted, I returned to talking about Fats and Cab.

Maybe the stupidest question I ever got was in New Orleans. It had been a very long day. There was a photo session involved, and it took hours. It was Ken's birthday. He claimed exemption and took off, showing up at the club in time for the show, very drunk and covered in one-dollar

bills pinned to his jacket. As I was taking a smoke break on a stoop across the street from the photo shoot, a female cop walked by.

"Nice day," I said, because it was a nice day.

"Yeah," she snorted. "For a *murder*."

I went back in, was placed in front of a mural of a naked girl with devil horns sitting in a martini glass, and was asked if there was sex in hell.

I was getting more and more interview requests. Katharine never really wanted to do them anyway, claiming she had nothing to say. While this may be true, it also helped lend an aura of mystery about her. Katharine was always the one to say no, and it often worked to our advantage. She insisted on touring only two weeks out of the month, while our friends in Ben Folds Five would go out for half a year or more.

We solidified our relationship with the Squirrel Brand Company, and took our first tour of their factory in Cambridge, Massachusetts. The whole place was a time machine. It was an elderly brick building with big green machines oozing out hot, undifferentiated Nut-Zippers. The people there were so nice. They stuffed our pockets with roasted peanuts and other confections, and showed us the ancient delivery van moldering in a garage. Back at the office, they produced a large acetate disc from the

safe. On it was original Squirrel Brand radio ads from the 1920s. We said we'd get them transferred to a modern format. Because of our success, the Squirrel Brand factory had maxed out their production. One day in 1997, the mayor of Cambridge hosted a celebration at the factory and called it Squirrel Nut Zipper Day.

As nice as that relationship was, the best part of my professional life was becoming friends with Al Casey. When I was in the city, I'd drop by to see him play his regular gig in Manhattan. The shows were sparsely attended. We booked a show with his band, the Harlem Jazz and Blues All-Stars, at Irving Plaza in New York. I watched them sound check, which was a real treat. Afterwards, Ken and I had a chat with the pianist.

"Did you know Fats Waller?" I asked.

"Oh, sure. I knew Fats. He was a beautiful guy."

"Can you play stride piano like him?"

The man started playing a song, striding like Fats used to do. Stride is a tricky style, like ragtime but more modern. You need a powerful left hand, because it bounces great big intervals in rhythm while the right hand plays the melody. Fats was a master of this technique. This guy was doing it right. He started off stating a simple, familiar melody and then began improvising. Each chorus became more and more intricate and unhinged until he wrapped

it up with a dazzling flourish. Ken and I applauded.

"What was that song?" I asked. I couldn't quite place it, but it was a classic.

"Oh, I just made that up," he chuckled.

Ken and I gave each other why-bother-being-a-musician looks and I headed down to talk to Al. He was puttering in the green room downstairs.

I did what I always did with Al in these days: follow him around like a puppy and ask detailed questions about Waller minutiae. It was like Chris Farley interviewing Paul McCartney on the old Saturday Night Live. "Re. . . remember that background stuff you played on 'Let's Get Away from It All' in 1943? That was awesome!" It really was like that. Meanwhile, the man was trying to pee, and I stood outside the door gushing away. Finally Al emerged, looking annoyed.

"Will you *stop* with that shit?" he said, looking me right in the eye. That's when we became friends.

I had already written a song about the man, "Pallin' With Al." We'd recorded it during the *Perennial Favorites* sessions the previous year. I was proud of the song. It was the first unapologetically happy thing I ever wrote. I had tried to compose a bridge worthy of Fats (he always wrote the best bridges) and had kind of pulled it off. The lyrics were good too.

*All the birds up in the trees have got a different song
 to sing
And it's better now they've learned that swing
They've been pallin' with Al*

*Down below at the candy shop they're still working at
 that same old chore
But their stuff is sweeter than it was before
'Cause they're pallin' with Al*

*Who's that man that's got the sentimental swing?
Plays that mess just like it doesn't mean a thing
Gather 'round y'all and watch him pluck those
 strings
When he get the right hand pumping
All them kiddies got to start buck jumping*

"Buck Jumping" was Al's signature tune. He told me that right after he got into Fats' band, he showed up late for a gig, drunk. He should have lost his job, but Fats decided to teach him a lesson.

"Ladies and gentlemen," he said to the crowd, looking at Al, "I'm pleased to feature Mr. Al Casey on this next number, which is his new composition!"

Trouble was, Al hadn't written a damn thing. He was on the spot. He took his place, told the guys "Blues in G" and a great little tune came out. Fats liked it so much they recorded it and scored a minor hit. Buck Jumping is also a dance they still do in New Orleans. You just sort of let your feet fly, as if the sidewalk is icy.

I told Al that I had lifted his little descending chorded intro from "Buck Jumping" and used it for "Pallin' with Al." I hoped he didn't mind.

"Oh, steal from the best, that's my motto!" he said.

Al agreed to sit in on "Pallin' with Al" that night. He sat on a chair in front of the drum kit. Before we started, I tried to show him the changes to the bridge, which are a little tricky.

"Just play through one time and I'll latch on," he said.

He certainly did, and took a couple solos. The crowd went nuts, and I turned my back so they wouldn't see the tears streaming down my face. This, friends, is as good as it got, a dream come true. Nothing that ever happened afterward in my professional life came close to this moment for me, and I'll take that feeling of total joy and gratitude to my grave.

We met up with Al every time we were in town. In the green room of *Late Night with Conan O'Brien* he thumped the back of my tired old 1938 Recording King acoustic,

saying, "That's a good box!" Later that afternoon he told me about seeing Big Bill Broonzy when he was a kid. I didn't even want to leave to do the show. Al was there when we opened for Tony Bennett at Radio City Music Hall, and I introduced the two. That was more fun than the performance itself—the crowd didn't know what to make of us. They were all seated, sober and wealthy, three things no Squirrel Nut Zipper audience ever was. There was a big elevator that lowered the whole band down below the stage after our set. I saluted as we went, feeling like the captain of a sinking ship. That got a laugh.

We started getting endorsement deals in 1998, which meant free gear. Epiphone guitars extended an offer, and I still play my beloved Emperor Regent. We convinced them to give a guitar to Al too, and we presented it to him at the Roseland Ballroom, where we were playing that night. He was very gracious and a little nonplussed, as he always was at our enthusiasm. I just wanted to show him he was loved, respected, and remembered. Fats died when he was thirty-nine. He basically drank himself to death. Al was still in his twenties then. His career had some low points after that, as all do, but he never stopped playing altogether. I could never tell Rice Fitzpatrick he completed that long pass by giving me his Fake Book, but I communicated something similar to Al.

We could never stay too long in New York, and at some point had to get back on the road, which was becoming a depressing routine. We began to isolate ourselves, even on the bus. Jé, Katharine, and Jimbo took the front lounge. Jé was already married with two kids. Jim and Katharine were married as well, and a united front. This left the ne'er-do-wells in the back lounge: me, Kenny, Chris P, and Stu. We smoked, drank, and played video games.

In hotels, Ken and I bunked together. We were brothers, with a shared sense of humor and language. One of our stock phrases was "Aw hey, man." This was usually used as a signal of wild-eyed enthusiasm. Once, we speculated on the best thing to say if you came up to someone completely naked. My offering was, "Aw hey, man. I'm gonna punch you right in the mouth!"

It could also be used to express despair or helplessness. Ken and I ended several conversations this way as the band sputtered towards dissolution.

Chris P and Stu ran together because of their shared interest in alcohol and other refreshments. Their nights went later than ours.

Jimbo could move in both worlds, but tended to stick with Katharine. He seldom went to the bars after a gig, and if so turned in fairly early.

Chris P and Ken invented a game called Pest. The

object was to torment the other guy until he hit you. We once deadheaded to New York, getting into town at two in the morning during a torrential downpour. As we tried to book hotel rooms, Ken decided to play Pest with Chris P. He won because he got a chicken salad sandwich shoved in his face. Chris P, though, had a genius for it.

In 1996 we stayed in a strange hotel in Charlotte. It was more like a hospice. There was an emergency pull chain in the bathroom. One day I walked past an Indian house-keeper who was having an existential conversation with Katharine.

"Why do you put a Do Not Disturb sign on your door when you're not in the room?" he asked in his thick accent. "How can there be a Do Not Disturb sign when there is no one to disturb?"

We sat in the lobby on the morning when it was time to leave. Ken and I were hungover and starving. Chris P came sweeping into the lobby door with a big box of Kentucky Fried Chicken. The room was redolent with secret herbs and spices. Ken, beside himself, begged for a piece.

I knew better, and stuck with my Styrofoam cup of thin, bitter coffee and non-dairy creamer.

Chris P was imperious. "I got up early this morning and went out and got this," he told Ken testily. "You could have done that."

Ken was pathetic. "Please just give me one piece," he pleaded. "I'm so hungry."

It didn't help that Chris P was standing beside Ken. You could see the grease stains on the box.

This conversation went on until it was clear that Ken had no more dignity, because he actually started begging. "Okay, help yourself," said Chris P, tossing the box in Ken's lap. Ken flung it open and then sat and stared. He let out a sad chuckle.

I came over and looked. Inside the Kentucky Fried Chicken box was a mummified pigeon. You could see its rib bones in between the dried feathers. It had all been a brilliant and elaborate ruse. Chris P had found the dead bird at an earlier gig in South Carolina. He combined his own natural deviance with his knowledge of Ken's foibles to create the perfect ruse. His feigned rudeness at Ken's pestering was expertly done. Ken didn't hit him, but Chris P was the undisputed champion of Pest.

There were still moments of band unity. Sometimes, waiting for a set, we would all sit and sing songs together. I remember one lovely version of "Alabama Song" from The Threepenny Opera, performed as we sat on the metal steps by an outdoor festival stage. This camaraderie, though, faded away. I can't put my finger on an exact time, but it just receded as insularity advanced.

Katharine always said she was shy and I believe her. She didn't want to sing in front of people at first, let alone be in a touring band. She sat on a stool through most of our shows in the early days, claiming that being near the front of the stage gave her vertigo.

But soon it became hard for me to tell shyness from haughtiness. I once heard her describe Andrew Bird as "her favorite toy." I did know that Jim and Katharine very much felt like it was their band, even though we all did the work, and now I had the single. In the early days, after Katharine and I had a big blowout argument before a wedding gig, Jimbo told me that if that happened again he'd "break up the band."

Like the Indian Hare Krishna girls, people kept giving us gifts. Little handmade baubles, like the leather guitar pick pouches some woman presented us. One night, the tour manager came into the dressing room with a pair of shoes made for Katharine. They were regular sandals, decked out with glued-on plastic flowers and other doo-dads. We encouraged her to try them on.

"I'm not going to put my feet in there!" she said. "Those shoes might have acid in them!"

This was how Katharine coped. It was strange to me—did she mean acid, like the drug? The truth is that the situation had changed so rapidly that we found ourselves

increasingly relegated to the dressing rooms or the bus. It's not like we would have been mobbed, or were in physical danger, it's just that no one would have given us time to think. I generally thrived on the attention, and when I couldn't, I sat in the back lounge of the bus and rolled enough cigarettes for the coming day or two.

I often talked to fans after the show. Most of these people just wanted to say something nice. Some of it was quite touching, as they told me that our music helped them through a rough time, like the death of a parent. Usually it was, "We loved the show!"

Often they would preface these remarks with two stock phrases: "I bet you're sick of hearing this," or "I know you've heard this a million times." Then some lovely sentiment would follow. I started telling them, "I haven't heard that a million times, and never from you."

As we got famous, things became weirder. I talked to one young man after a performance, standing in the emptying hall in front of the stage.

"I just want you to know that I'm going to be this big one day," he said, looking at me strangely. "You better watch your back."

I regarded him for a moment and told him to be careful what he wished for.

Maybe I wished for it too—perhaps I had when I was

fourteen—but now I was living a life of attenuated adolescence. The practical jokes were taking a cruel edge. I was constantly high and drinking almost every night. Sounds like a good gig, but eating cake for dinner every night got old. The fact is I couldn't quite take any of it—the grind of the road, the increased attention, and especially the feeling that the band had irreparably fractured and was only being held together by external pressure.

We were famous, though it was all very modest. We were one of thirty bands to be certified platinum in 1997. Once, and only once, a girl screamed when she recognized me outside of a club in Boston. My reaction was to run like a rabbit back upstairs, much to Katharine's amusement.

It's hard to talk about fame, because it has mostly to do with other people's perception. I saw it happening and realized it didn't have much to do with me, or us. I guess the definition of fame is strangers knowing about you. Fame is hearing your song as a soundtrack to a Daisy Fuentes swimsuit party. Fame is standing behind the couch on the set of *The Tonight Show* where William H. Macy sits as he turns to you and says, "Beats digging ditches, don't it fellas?"

In the early summer of 1997, we signed up for a leg of the H.O.R.D.E tour. Our pals Ben Folds Five were on the bill too, and that's where I really got to know them. The headliner was Neil Young. I'd known about Neil since

I was barely in my teens, listening to Buffalo Springfield on headphones back in Burnsville. I'd heard much of his music since, and admired him a lot—especially his loopy, demented guitar solos.

On the first day of the tour, we sat on a hillside over-looking the tour bus parking lot. An older man with long thin hair, obviously a rock and roller, ambled over and sat at the bottom of the hill by a lamppost.

"Looka there," I said. "That's Neil Young."

Neil looked over his shoulder and smiled at us. We shifted uncomfortably.

"Wow, there he is," said Jimbo. After another minute, Neil looked back and smiled at us again. This time he waved. We waved back.

"I think he wants to hang out," I said, long after it was obvious. We walked down the hill.

I don't remember much of the conversation. I never expected to meet the man. We established that he was Neil Young and we were the Squirrel Nut Zippers. It turned out his disabled son, Ben, was a big fan. Neil told us that he and his wife liked our stuff too. He asked if I wrote the single, and I said yes. By this time I was trying to hide behind the lamppost.

"That damnation record—that's a really good record," he said, smiling.

I wanted to tell him about all his good records too, all those great songs of his that hit the emotional mark. "Thank you," was all that came out. Later, when we cranked into our opening number, "Bad Businessman," I looked behind me from the baritone sax chair and there was Neil, checking us out. It was great and made me want to throw up a little.

Once, in the pressroom of some performance shed, I told an interviewer that H.O.R.D.E was kind of like a mobile prison camp. I didn't mean it to sound harsh, but it was kind of true. You couldn't actually *go* anywhere. These were big outdoor venues, away from any city. You hung around on the bus, or walked through the crowd, or saw your new friends play. I really liked the guys from Morphine, who were laid back and very nice, until show time, when they went feral.

Occasionally, it got hairy. In Florida, we played to a packed crowd who were surrounded on three sides by ten-foot concrete walls. In front of the stage were more of those metal barricades. It got rowdy, and dangerous. We thought people were going to get hurt, but played anyway.

My fondest memories are having access to the side of the stage when Neil played. He would take the last note of the closing band on the second stage and repeat it, turning that into feedback. Then he was off, with Crazy Horse

stomping around behind him. They were friendly guys off stage, and complete maniacs on. Neil wrung the most remarkable, twisted howls from his guitar as the sun went down.

One of the bands on that tour was Leftover Salmon. We may have been crazy, but these guys were insane. There would be fistfights outside their bus between some dude's girlfriend and his wife. In the front lounge of their bus, they didn't have a coffee maker. They had a blender, for margaritas. The back lounge was for the harder stuff. I sat back there once, declining most of the substances offered to me, and watched two amazing videos. One was of William Shatner performing Elton John and Bernie Taupin's "Rocket Man" in the 1970s. The other was a 1960s newsreel of people using dynamite to blow up a dead beached whale.

Stu ran with these guys. It wasn't advisable. They would steal a venue's golf cart and go on disruptive raids of the acoustic stage. One night they all tripped on acid and went to see Neil Young's set.

Stu stood with the others at the top of the amphitheater. Far down below, the roadies were setting up the stage. They brought out a Hammond organ, with an angel on top cut out of wood. In his altered state, Stu thought they were rolling Neil's son Ben out in his wheelchair to put him on

display or something. He was horrified.

"Do you see that?" he asked indignantly. "What—what are they *doing*?"

No one saw it, of course, because it wasn't happening. People started drifting away from Stu, who continued his tirade.

"*What goes through a man's mind?*" he cried with a dramatic gesture. Stu was having a philosophical crisis.

Stu stomped down towards the stage to put a stop to the imagined outrage. When he figured it out and sheepishly returned, he'd been deserted. Later that night he led security in a Keystone Kops golf cart chase.

We did *The Late Show with David Letterman* in June. We were grateful to be in the Ed Sullivan Theater, where the Beatles played. It was freezing in there. We were told several things by a producer, namely not to have anything to do with Mr. Letterman.

"Don't talk to Mr. Letterman in the hall. Don't ride with Mr. Letterman in the elevator."

Paul Shaffer was another story. His band had been playing "Hell" when the show went to a commercial. I was really flattered. I remember seeing Paul on *Saturday Night Live* when I got to stay up late because my parents were out playing bridge. He was very friendly and approachable. We shook hands and chatted.

"Thanks for playing 'Hell' as a bumper," I said. "You guys do a great job."

"Ah, Tom," he said in his nasally voice. "We sound like a goddamn high school bar mitzvah band!"

I asked Paul if he would sit in with us that night. He was excited. During sound check he played some great stuff. I decided to fuck with him.

"Hey, Paul," I said after a run-through. "No need to hold back. You should really go for broke."

"Really? Okay!"

He must have taken this seriously, because during the performance his solo was spectacular. When he finished, he looked up at me beaming, as if he was a kid who had just won a Little League game. I flashed him a big thumbs-up.

Mr. Letterman was not so enthusiastic. As we tore into the second verse, I looked over my left shoulder. He was seated at his desk in the dark, cradling his head in his hands.

Afterward, we went to a club in Manhattan to watch the performance when it aired. Ken and I almost got kicked out for trying to smoke pot, which just goes to show.

That version of "Hell" might have been the best we ever gave, certainly the best on television. Jimbo wore an old man mask and threw Chinese New Year money in the air and it fluttered down like confetti.

One day that summer, after the tour, Ken and I were bunked in a New York hotel. He had been out getting coffee. "Read this," he said when he came back into the room, throwing a newspaper on the bed. I looked at the article he pointed out.

Disney Buys Mammoth Records for $26 Million
Expects to Recoup from Squirrel Nut Zippers

I called Steve Balcom, a Mammoth Records executive. Steve basically ran the label. We had a good relationship. Steve never bullshitted me, much. We occasionally screamed at each other for bad decisions that neither of us was responsible for, and in high-pressure situations that's not a total loss. This time it was my turn.

"Why the fuck did Mammoth sell out to Disney? They're the cultural devil!"

Steve basically gave me some version of "Deal with it." I really didn't like Disney. They were litigious and almost single-handedly changed public domain laws so Walt could hang on to his cartoon characters. They weren't doing anything especially artistically impressive. Their strategy was to re-release films from their glory days and maximize profit. I wasn't into their recycled fairytales and strict gender typing. Their label, Hollywood Records, had lost millions for

years with nothing to show. They signed Insane Clown Posse without quite understanding that the band wasn't, um, Disney material. It was an industry joke.

Disney bought Mammoth for a needed shot in the arm. Mammoth sold itself to try to crack into the movie industry. The Squirrel Nut Zippers were nothing more than the latest big-seller for the label. Disney expected to recoup from somebody, and chose us. Other than that, we didn't fit into the picture.

There wasn't much reason to trust Mammoth. There were several people who worked there—Keith and Lane, among others—who really cared about the band, but they didn't call the shots. Beyond that, the feeling I got was that Mammoth saw any band on their roster as mules on the company farm. The mule pulls the plow. It's not necessary for the farmer to sit the mule down and tell him what's being planted, or invite him into the farmhouse for dinner with the wife.

Mammoth had no intention of releasing *Perennial Favorites* in 1997, or even of giving us a release date. By this time they were about to be in breach of contract. We were going to work *Hot* for the foreseeable future with no idea when things would change. We talked about getting out of our record deal. Surely there was a major label out there that would offer better terms. Meanwhile, we insisted that

Mammoth issue *something*. The *Sold Out* EP was released in 1997. It contained some great live tracks, an early version of "Pallin' with Al," and a couple of those old Squirrel Brand radio spots from the 20s.

I could have handled all this better if the success of my song wasn't such an obvious strain on the band. If you thought, as I did, that we were all in it together, then it wouldn't have been a problem. Instead, it appeared to be some kind of threat to the band dynamic. Maybe releasing *Perennial* could bring some balance, but the release date had been taken off the table.

I know there are many people who would love to be gathered into such a corporate bosom. I'm not one of them, and suspected we were going to be Disneyfied. It was good that we appealed to all ages, but there was a creepy element to the band, something volatile, that I didn't want papered over. I didn't want to end up singing some song to a princess on a Disney soundtrack.

The next month, we were asked to sing a song to a princess on a Disney soundtrack.

Shortly after Disney's acquisition, representatives from The Squirrel Brand Company visited us in North Carolina. They presented a licensing agreement, which asked for a percentage of our gross receipts. We were stunned. They were already reaping the benefits of our

success, as their production was maxed out. We already had their letter from 1994 giving us permission to use the name. It was decided to make them a much less generous counteroffer.

Meantime, there was other baggage we were being asked to carry. When "Hell" broke, it took everyone by surprise, not just us. The lyrics, the melody, the style and the production values were obstinately different from, say, Hanson. I took it as a good sign. Maybe this would break mainstream radio open a little bit and make room for diversity. No such luck. A new trend was identified, called Swing. We were the poster children because we were selling records—as many as 30,000 a week by the summer of 1997. There were quite a few bands on the West Coast with whom we were compared. These guys came up playing rockabilly and ska. Theirs was a scene with strict uniformity. Girls wore Bettie Page-style hairdos with bangs; the guys had pompadours and tattoos. They traded their rockabilly jeans for zoot suits. Their brand of music was mostly Jump Blues with Krupa's "Sing, Sing, Sing" backbeat. It all seemed pretty one-dimensional to me, and all the more strange that we were somehow tapped as the spokesmen for this movement. "Hell" was a calypso, after all, and the Zippers' music willfully diverse. This didn't fit well into the media narrative. To give you an idea, I fed all 78,000

interviews I did in the Zippers into a special computer program and synthesized them into representative yearly samples, which follow. (I totally did not do this.)

1995

Interviewer: You guys are strange. What a funny name! Hey, there are other bands that are also strange. Have you heard Combustible Edison? How about Pink Martini?

Tom: Yes, I've heard them. It's cool that they play different kinds of instruments.

Interviewer: They play Lounge Music. Your group is also part of this Lounge Movement. Do you drink martinis? That one band has "martini" in its name. You should smoke cigars too, being a Lounge band and all.

1996

Interviewer: I like your new record. It makes me think of scratchy 78s and a bathtub filled with gin. What a funny name! You don't really sound like anybody else.

Tom: Thank you. Have you ever heard of Tom Waits or the Cheap Suit Serenaders? I like Fats Waller.

Interviewer: That just underscores your ultra-hip, underground, alternative credibility. *Pitchfork* loves you!

1997

Interviewer: Ow! Your funny-named candy pulled my molar out! Look at you—you're famous! This whole Swing Revival is something else, huh? What do you think of all those bands with "Daddy" in their name? They write songs about wearing zoot suits. I like to think of you wearing a zoot suit, smoking a cigar, and drinking a martini while sitting in a bathtub full of gin.

Tom: I don't think we're a Swing band, really.

Interviewer: That's sounds contrarian, but not in a cool way. Aren't you hep to the jive, swinging Daddy? This fad is going to last forever and ever! Now put this on and get into the bathtub for the photo session.

Tom: I'm tired.

1998

Interviewer: So: you're the Swing band that doesn't want to be called a Swing band. What's your big fucking problem? Do you drink martinis all night just so you can

pee in everybody's corn flakes in the morning?

Tom: Aw hey, man. I'm gonna punch you right in the mouth!

There was a new subset of people coming to our shows. They dressed in a kind of uniform. The men sported two-tone shoes, suspenders, high-waisted pants, wide silk ties and fedoras. The women wore clunky heels, printed dresses, heavy red lipstick and Bettie Page bangs. They would push their way to the front of the stage and aggressively clear a space, alienating the regular fans. During the show, they danced the Lindy Hop and the Charleston, flinging each other around and making "hot-cha" jazz hands. Sometimes they would admonish us for our tempos being too fast. We called them the Swing Nazis.

We made our first European tour in March of 1998, one marred by cold weather and chilly relations. We were exhausted and burned out, playing mostly for Americans because none of our records were in the stores. "Tom, your records have been released over here, they're just not available yet," one label rep told me patronizingly. It took balls to form that sentence so I decided not to smack him.

Right after we arrived in Malmö, Sweden, Mel called to say that Stacy was in the hospital. By the time we got to

Düsseldorf, he was dead. We finished the tour in a home-sick daze.

Several years before, I sat with Jimbo on my crapped-out couch in Carrboro as we watched Nirvana perform on *Saturday Night Live* and pronounced the death of Grunge. It was our turn in 1998. The Gap clothing company ran an ad called "Khaki Swing." In it, a bunch of swing dancers hit the floor, all smiles. They reminded me of the Swing Nazis, except they weren't wearing the typical uniform. Instead, most of them wore khaki pants, which was jarring. The ad was filmed in a modern, interesting way. The soundtrack was "Jump, Jive, and Wail" by the great Louis Prima, recorded in the early 50s. I loved his songs for Disney's *The Jungle Book* when I was a little kid, still living in Florida. (Prima, by the way, wrote, "Sing Sing Sing.") If what I heard was true, Brian Setzer held up the release of his new record so he could add a hastily recorded version of "Jump, Jive, and Wail" as a result of the ad. I think Big Bad Voodoo Daddy also covered it. I watched the commercial sitting by myself on a less ratty couch in Pittsboro. Time appears to stop in the middle of a couple spectacular moves—the image freezes, but then rotates, so it can be seen from many angles. Then back to the action. At the end, a white card appears, upon which is written "Khakis swing."

"Well, that's that," I said, to no one in particular.

www.ingramcontent.com/pod-product-compliance
Lightning Source LLC
Chambersburg PA
CBHW060326050426
42449CB00011B/2668